The Accident of Art

Sylvère Lotringer / Paul Virilio

Translated by Michael Taormina

Table of Contents

A Pitiless Art?

A Pitiless Art?

Supermart □ Terrorist and Terrorized □ Disfigured Art □ The Iconoclasm of Presentation □ Colluding with Destruction □ The Voice of Silence □ Making Images Speak □ The Face of the Figureless □ The Arts of Disappearance

Sylvère Lotringer: *You've been trained as a physicist. You can understand science from the inside. Science happens to be your best enemy.*

Paul Virilio: Today there are many mathematicians, but few physicists. A friend of mine, Michel Cassé, an astrophysicist, just brought out a book called *Du Vide et de la création* [Of Void and Creation][1] in which he talks about quantum systems. And he wrote: "Clearly, astrophysics today, the research into the universe, is mathematical: it happens at a highly specialized level. But as to whether it still is physics or not, well, I don't think there is any way of telling any more..." Einstein managed to maintain both, but astrophysicists today have taken off...

We could say pretty much the same about art.

About art... You know, I think you're right.

Supermart

Art today has become a highly specialized profession. There are powerful museums and galleries, throngs of curators, art critics, art magazines, all spreading the word with an evangelical fervor. New biennales are being born everyday in the most unlikely places. The world is becoming a boundless supermart: *"A place where art meets consumerism and where purchasing becomes an art." No one would dream of questioning art's right to exist anymore. But whether what's being produced today is art or not... You recently published an essay,* Le Protocole silence *[Art and Fear] in which you challenged the art of the 20th century. Your book has been harshly criticized in France and elsewhere, just like Baudrillard's pamphlet,* The Conspiracy of Art.[2] *Both of you are now considered the enemies of contemporary art—and all the more sought after because of that. But I am not sure that what you said has really been heard.*

Actually the French title for *Art and Fear* isn't "le protocole silence," but *La Procédure silence.*[3] Yet you're quite right to use the word "protocol," because it is not exactly a book. It brings together two talks I gave on contemporary art at the request of Jean-Louis Prat (the book is dedicated to him). Jacques Derrida and Jean Baudrillard had already made an appearance and Prat suggested that I should take my turn. But he told me: "You happen to have known everybody, Braque, Matisse—I worked with them, which is pretty rare—all the abstractionists, Max Ernst, Viera da Silva, Poliakoff, Rouault, Bazaine, etc., so I would like you to talk about art." I wasn't thinking about doing that at all. Just look at my books: I'm into speed and other stuff. I don't discuss art.

You wrote recently a long catalog essay on Peter Klasen, the German "realist" painter.[4]

I've known Klasen for twenty years, and I have been thinking about writing this text for a long time. I could have written it twenty years ago, but the occasion didn't present itself until recently.

You've often mentioned the Italian Futurists, but it is true that you're mainly interested in them because of their enthusiastic embrace of technology and fascism, as well as Marinetti's aero-mythology. You never talked about the group's paintings. So this book is a first for you. You've written on cinema and war, so it is surprising you wouldn't have tackled art before.

So I accepted the challenge. I told myself I could take a retrospective look at contemporary art through my lived experience. These talks are those of an individual looking back on his century at its close. I wrote them in 1999, just after finishing *The Strategy of Deception*[5] on the war in Kosovo, a genuine book on warfare.

Terrorist and Terrorized

The war in Kosovo, as Marinetti would have said lyrically, was won "from high in the sky." Actually Marinetti was flying just a few feet over the rooftops in Rome. His Futurist Manifestoes *were written on the eve of WWI. It didn't take long before the planes were used for bombing in Africa and in Ethiopia, and then in the sprawling European battlefields. As for us, of course, we are moving rapidly towards the militarization of circumterrestrial space and orbital strategies, a kind of cosmic panopticon capable of unleashing terror from on high*

through the electromagnetic ether. There's no more futurist avant-garde, or artistic avant-gardes to speak of, as if the future had already moved behind us. Do you think art has kept apace with the exponential development of war and technology, or has been deeply affected by it?

Thinking about it all I realized that the art of the 20th century is basically terrorist, and terrorized. And I would say it is both. It has been devastated by the two World Wars, by the Holocaust, by techno-nuclear power, etc. You can't understand Dada or Surrealism without World War I.

It was the first assembly-line massacre on a cosmic scale.

It was the relationship to death, the accumulation of dead bodies on the battlefield. The inventor, so to speak, of German Expressionism is Otto Dix—I would call him its certified inventor because he experienced this pitiless century in the battles of the Somme Valley, in the mud, in the shit that he translated in his art. And do you know who he was pitted against in that battle? Georges Braque. I worked with Braque on the Chapelle de Varangéville, so it all hangs together. Braque and Otto Dix, the two men facing off at the mouth of the Somme River: Braque brought us Cubism, which is a form of deconstruction, and Otto Dix brought us German Expressionism. We stepped into an art that already was the victim of war, and which, of course, did not recognize itself as such. When they saw camouflaged tanks, Picasso told Braque, "*We* are the ones who did that." Yet they did not understand that the Cubists were not the creators of camouflage; they were the victims of the deconstruction of World War I.

According to you, Cubism then wasn't just a formalist experiment inscribed in the history of art or in the destruction of perspective, as it is commonly envisaged, it was artistic realism, like Peter Klasen's work is technological realism. WWI blew reality into pieces and Braque collected them in his paintings the way people collect pieces of flesh after the explosion of a human bomb.

No doubt about that. Now onto the Surrealists. Surrealism has been idealized by all these exhibitions, by the advertising slogans of cultural salesmen while I maintain that it was a victim of war through Dadaism. When Huelsenbeck in 1918 said, "There isn't enough cruelty; we want more violence, more war; we were for the war and continue to support it"—somehow that was proof that they were contaminated, alienated war victims.

Huelsenbeck was just upping the ante on the unbelievable violence that had been unleashed by war technology on the helpless foot-soldiers in the trenches, and it clearly shows that Dada's revulsion toward war remained visceral. It was certainly central to the entire movement. It is not mere chance that Dada was born in Zurich, in neutral ground. The rest of Europe, sold to shoddy patriotism and colonial greed, was becoming a living hell.

We're really sick of hearing about the Surrealists's dreams and "merveilleux." The Surrealists were war casualties, they were "broken faces." [The French expression, *gueules cassées*, became emblematic of soldiers disfigured by shells.] Mr. Breton and Mr. Aragon are broken faces, nothing less.

Both were assigned to military hospitals during the war and that must have been a pretty ugly sight. The first book André Breton and Paul Eluard published was The Magnetic Fields. *They could have called it the "mined fields", or the "killing fields." It was all about delirium, and the entire generation, those who survived the onslaught, had literally been shell-shocked. Automatic writing became their machine-gun.*

When you look at Aragon's political history, you can tell that his experience of the war extended into communism. Let us continue: World War II. Abstraction, *disfiguration*. You can't understand abstraction without war—or rather the two wars. I love abstract painting, don't get me wrong, but it is a disfiguration. They made the face disappear, which reminds us of other exterminations where bodies were made to disappear. And on the other hand, there was Viennese Actionism, a capital movement. Otto Muehl was a genius of a painter. Hermann Nitsch, Schwarzkogler... and many others. What did they invent? Body art, self-mutilation, self-torture. This accounts for the continual inflation of super-violence in German Expressionism and also the practices of body-art, like those of Orlan and my friend Stelarc, the two best known body artists, the duo. You can't understand the Viennese Actionists without torture. Joseph Beuys, who was he? He was a bombardier, and I love Beuys. But you can't understand Beuys if you're not aware of the fact that he was a Stukas pilot. Beuys was conscious that he was a war victim. And Otto Muehl, what did he do during the war? You can't understand Otto Muehl if you don't realize that he was a Wehrmacht soldier and fought against Private Ryan on the beaches in Normandy, etc. Contemporary art has been a war victim through Surrealism, Expressionism, Viennese Actionism, and terrorism

today. Now it is time to recognize that we are the products of major accidents, and war is one of them. But today, accident and war are just one and the same thing. You just have to look at the World Trade Center. Not being an art critic myself I decided that I would try and translate all of that. In essence that's what the book is about.

Art is war by other means.

Art is the casualty of war. So don't let anyone bug me with the crisis of contemporary art. The most contemporary thing about contemporary art is its crisis. And we could segue with terrorism in the present. I am willing to show the associations between terrorism and so-called contemporary art. The day contemporary art recognizes itself as a casualty of war, we can start talking again.

Instead of painting elaborate camouflage…

Instead of making camouflage. You found the right expression.

So that is what art would be. Painted faces, broken perceptions, make-up art. In this compulsion to camouflage, there would be no recognition that the wound is bleeding right under the paint.

That there is a wound, that there are stigmas, that there is trauma. They should reread Freud's writings on death. They should reread *Civilization and its Discontents*. If there ever was a time for that… Mind you, I am not a Freudian, that is not in my nature. I belong to a technological and military culture, not a psychoanalytic one. I am not like Jean Baudrillard, but I still have gone back to Freud, and I must say that it did enlighten me.

Disfigured Art

In 1930 Freud theorized that there was an aggressive instinct that keeps threatening civilized society with disintegration. But he acknowledged as well that the external world had a lot to do with it, as it is "raging against us with overwhelming and merciless forces of destruction." Although Freud saw the death instinct as something innate, a "primary mutual hostility," death always comes from the outside. Freud explicitly referred to the horrors of the two World Wars.

It is amazing the extent to which psychoanalysis has not broken away from its beginnings. For me there are two Freuds. The first is the theorist of the unconscious; and then there's the theorist of the death drive. Trauma and the death drive came out of WWI. You can't understand this new dimension without it. Precisely at the time something started to crack; culture and contemporary art were deeply impacted by it. Psychoanalysis turned to the death drive, it had no other choice. You can't really speak of a "huge massacre," the way French Premier Lionel Jospin did about the "Chemin des Dames," without invoking of the death drive. [Jospin finally cleared the name of all the French soldiers executed by the military police on the "Dames' Way" for having deserted the front.] In its own bizarre way the War in 1914 already was an insane slaughter, wave after wave of people jumping off from the trenches for an all-out assault against an invisible enemy and each time mowed down by machine guns—two hundred rush out in the open, instantly decimated; they sent two hundred more, trampling on the dead, etc. The army moved a few kilometers at the cost of thousands of men's lives. Generals would say, "Give me three thousand more men and we'll grab one more mile; with thirty thousand, we will take over three." It already was delirium.

That's how Voyage to the End of the Night *starts: the senseless killings, the insanity of it all. You remember Céline's famous 1934 speech in Médan... "In the game of humanity, the death instinct, the silent instinct, is definitely well-positioned... You would have to be endowed with a truly bizarre style to speak of anything else than death these days. On earth, on the seas, in the air, now and in the future, there is nothing but death." Céline was wounded on his horse during WWI. Later on in Vienna, he was introduced to psychoanalytical circles, and by Wilhelm Reich's wife no less. He saw Germany on the edge of the abyss... Céline got the idea right away, as Reich did, that the masses were not fooled or oppressed; they were throwing themselves eagerly into the jaws of death.*

You can't understand the 20th century without the death drive.

Still you have to admit that the death drive is triggered by something. You trip the switch and it all fires up, but first something has to trip the switch. Céline fathomed the deep desire for nothingness entrenched inside human beings, but he recognized that the "unanimous amorous, almost irresistible impatience for death"[6] among the hystericized masses was almost always stimulated, provoked and held by stupidity and brutality. It fed all the way into the Führer's "suicidal state."

This is something that comes out of the War in 1914. Take another war victim: Bazaine, the abstract painter I knew and who also used to make stained-glass—I didn't make any with him. They said to him, "Hey, you've become abstract." And he would answer, "Yes, you could call it that." But he preferred the term "non-figurative." He insisted that "abstract doesn't fit me." So they asked him when did this happen. "After the war," he replied, "my painting diverged all by itself." I wrote it down.

I assume it wasn't the kind of diverging painters experienced at the end of the 19th century when confronted with the invention of photography.

No, no. In the first instance, technology made the divergence unavoidable: heliography, or light figured by itself through the stenotype, and later figured on photosensitive substances. In the second, a social trauma caused figuration to diverge. *Disfiguration* —when Bazaine says "non figurative," that's what he means. The war is disfiguring art, the way it destroyed and smashed the Rheims cathedral and later on destroyed Oradour-sur-Glane.[7] War does not simply destroy bodies with shells and bombs, it destroys outdoor spaces as well.

It's land art on a huge scale.

Just look at the hills in Champagne today compared to what they were before, when they had trees. So there is a disfiguration of war that will move over into art, independently of Cézanne's or anyone else's theories. When you read Kandisky and others who invented abstract art—what do you hear about them? Everyone says that they came to it through music, for example.

Actually Klee played the violin, even came from a family of musicians. He painted for the birds, like Paolo Uccello.

Of course, music was really important... But that's not all there is. Disfiguring events happened in the 20th century. Nothing but disfiguring events.

For those who were disfigured, disfiguration must have been a sort of figuration then. Abstract art would have to be looked at in an entirely different way.

Yes, Rothko says as much: "I can no longer use the figure without destroying it, so I'd rather be abstract." I've known many other abstract painters, including de Staël, but for me Rothko was the greatest.

So according to you, abstract art wouldn't merely have abstracted itself from representation; it would have devised means by which it could be level with the horror. Art running away from destruction, or preempting it retroactively by cleaning the slates.

Abstract art is not abstract, it is an art of retreat. I was much criticized in the French press for my book. The editorialists said that I didn't understand anything about art. Get lost, I felt like telling them: you don't understand anything about the *culture* of art. You're specialists of this painter, of that style, of this genre, but you're incapable of articulating what emerges in an entire period.

There's the culture of art as there's the culture of death, and in the 20th century the two came together.

Anthony Blunt is a great art critic. (He is one of those English spies who defected to the Soviet Union, him and his two friends, Burgess and MacLean.) When Blunt deals with the Renaissance, he gets inside the art in an extraordinary way. But he doesn't do criticism on Fernand Léger, he does *art* criticism. My book isn't art criticism.

In terms of criticism, your claim is pretty extreme. You're bringing all these disparate strains down to a single traumatic factor. It is certainly a powerful one, but is it sufficient to account for the whole range of the century's art?

Yes, I maintain that it's art as the victim. You can say that human beings in the 20th century were impacted because they had certain political opinions, because they belonged to particular races, etc., and it is true, I'm not denying it. But they were victims in one way or another and *without exception*. Paul Celan, one of the last great poets I loved, is the perfect illustration. Art was mortally wounded like the rest, and we haven't recovered from this wound; on the contrary, we're wallowing in it under the pretence of Actionism, protest. We haven't recovered from this victimology. Contemporary art is victimological, and it doesn't acknowledge the fact. It is beginning to enjoy its situation in the world instead of screaming in pain.

Artists and writers who came before WWII, "high modernists," as they are usually called, like Antonin Artaud or Simone Weil, bore witness of the catastrophe ahead of time. They attempted to ward it off by putting themselves on the line. The exhibitionists came later.

Curiously, they showed up after World War II. For my money, the Viennese Actionists are exhibitionists who have nothing in common with Artaud or Otto Dix, those who suffered. They're playing with the detachment of a dandy—just like the SS.

The Iconoclasm of Presentation

At the beginning of Art and Fear, *you cited the remark made by Jacqueline Lichtenstein after she returned from a visit to Auschwitz.*

She saw the glass cases with the piles of suitcases, the mounds of dentures and eyeglasses, and she wasn't overwhelmed by them...

No, she wasn't. She felt like she was in a contemporary museum.

And you made this devastating remark: contemporary for whom?

She has some excellent things to say.

Her observation is interesting in several ways. First there's the obvious: Christian Boltanski, the clothes installations, shoe boxes stacked on rows and rows of bunk beds, etc. The drugstore of death. But in some way the reference here is being reversed. The Auschwitz installations can be seen as a template for contemporary art. Nowadays, whenever you pile up objects, you seem to be referring to the Holocaust, documenting the devastations of the century. A heap of objects, like Arman's pile of suitcases in front of the Gare Saint-Lazare in Paris—in front of a railway station, no less— instantly suggests inhumanity. And I'm sure Arman didn't see it that way, being a humorist of sort. It must have been for him a modern version of the Egyptian needle. And yet the gruesome reference imposes itself. Recently they had an exhibit inside the Gare du Nord with the pictures of all the families rounded up at the Vel d'Hiv in Paris in July 1942 and shipped by train to Auschwitz. Recently I arrived there by train from the Charles de Gaulle Airport and by the exit I suddenly saw hundreds of pictures lined up on panels with the people's name, ages and addresses. I was devastated. I could have been there. Accumulation is the art of the assembly-line—Heidegger's celebrated sentence (the only one he consented to say) on the factory-camps. Museums also are assembly-lines.

It's concentration, in the sense of concentration camp.

More recently Rebecca Horn elegantly figured a pile of corpses by stacking a dozen violins at the end of a piece of railroad track for her Holocaust memorial in Weimar. On the other side of a plate glass behind the track you could see heaps of sawdust of different colors. It was exquisite, and deeply obscene. I wish she had extended the tracks all the way from Goethe's House nearby all the way to Buchenwald, scarring the lush German countryside. The Nazis went all the way, why stop short at these guarded metaphors? What is missing from contemporary art is that it does not recognize death and suffering. Consequently it ends up being dead itself.

It is dead, and above all, it has forgotten tragedy. Art is not free from tragedy. It is extraordinary to see to what extent accident was censured in the name of the cult of happiness, the cult of success. Comedy has dominated to the point that tragedy was erased. What remains of tragedy today, especially in France? Nothing. There are no tragic authors. They are considered to be pessimists. Consumer society demands optimism. When Beckett came to France, what did he write? *Waiting for Godot.* What did the French do with it? They turned it into a comic play. What we're seeing now is the return of tragedy. The first text I turned to when I started writing was *The Birth of Tragedy.* And what is so wonderful about it is that Nietzsche reveals that democracy was born in the face of tragedy. He says it: the tragic choir is the birth of democracy. In the face of the heroes' madness, Creon, Antigone, Oedipus, etc., the tragic choir debates. It is high time we reinvented a relationship to tragedy in painting, literature, philosophy and politics, all at the same time. At present everyone is talking about dirty wars, the dirty Chetchen war, Bush's dirty war in Iraq, but at the same time, terrorists and martyrs are idealized. We did the same with our

soldiers in 1914. But no. The terrorists are not pure. War must be waged against them. This does not mean that I agree with the war in Iraq, not at all. The terrorists are one thing, and the terrorized another, but what is extraordinary is that the terrorized are beginning to resemble the terrorists, like the victim resembles the executioner. It is the victims' way of protecting themselves. The victim sees himself or herself as an executioner.

Does this apply as well to the attack on the World Trade Center? Baudrillard called it "a terrorist situational transfer," the terrorist response to the terrorism of global power—terror against terror.[8] Would you consider this a case of "a victimization situational transfer"—victims against victims?

With the World Trade Center, we have an iconoclastic phenomenon and no one foresaw it. There are two types of iconoclasm, at least the second one has just appeared. There is an iconoclasm of representation. Just as there was the auto-da-fés and the destruction of statues and cathedrals during the French revolution, there was the iconoclasm of destroying the Buddhas of Bamyan. The Taliban and Bin Laden did the same thing, first with the Buddhas and then with the World Trade Center. The World Trade Center was the icon of capitalist representation: Wall Street. There were two of them. There was an iconoclasm of the representation of capitalism after the representation of Buddhism.

The twin idols of the two world religions standing tall. The religion of money and the religion of the cosmos.

Right, but a second was created: the iconoclasm of *presentation*, the constant, worldwide replay on every channel of the impacts on the

Twin Towers. We were not informed, we were frozen in front of a single message generalized on a world-wide scale. This tele-presence in reality is an iconoclasm of real presence, because we only saw one thing. Everyone knows that we need two eyes in order to see anything in relief and make a choice. Anyone who aims a gun knows this. In that case, we only had one eye, a "big optic" on the global scale. The *single* big optic. Solitary vision is an iconoclasm of presentation.

But isn't that what tele-presence does anyway, even if it doesn't focus obsessively on one solitary event? It's the illusion of "being there," the mirage of the live image.

To go from representation to presentation is to lose distance. All ancient art, whether they are primitive, civilized, savage or naive, are arts of representation. The end of representation has happened in the press and the media, *and it's going to happen in art.* Let me explain: the essence of the press is its being old news a day later. The day after, a newspaper from the day before is totally devoid of interest. The Daily is today. Of course, with live coverage, in real time, thanks to the speed of light, presentation replaces representation: now it's webcams, it's "reality-shows." Art today is doing the same thing. It no longer plays off distance. It's one of the levelings I am bringing out when I talk about the world: it's the pollution of distances, temporal distances and not simply spatial distances.

Colluding with Destruction

And even art today is threatened by this pollution. It just presents itself.

This is a major philosophical phenomenon. I have spoken with Jacques Derrida about this; he contested the term "presentation," telling me it isn't that, etc.

No wonder: Derrida's entire work involves the deconstruction of the "metaphysics of presence" in speech from Plato to Claude Lévi-Strauss. The claim that there could be such a thing as "real presence" as opposed to real-time simulacra goes against his very argument.

I am not a philosopher, I don't give a damn about philosophers. I am an essayist and I am working on my own turf. I say that tele-presence is a presentation. So, there you have it. I gave the first talk of the book, which is called "A Pitiless Art," by way of reference to Albert Camus—whom I discovered after WWII, during the occupation of Germany. I read *The Stranger* in the barracks at Freiburg, in the 50s, all in one shot. And what did Camus write? "The twentieth century, this pitiless century." So I went for the pitiful/pitiless side of things—*pius*, impious, in the sense of piety, since the two words are related. When someone tells you that you're impious, it doesn't mean that you're profane, it means you're pitiless. The words are inseparable. The word "pitiful," you'll notice, means pathetic or shabby, whereas to be pitiless is to show some character. So there you have yet another perversion. The Latin word "pius" is what gives some popes their names: Pope *Pius*. It doesn't mean holy, it means "he who takes pity on." It means that you show or have pity. So you will invoke the Inquisition, alright. But what I mean is that it is a criterion of what we analyze, just as it is for the sublime. They are the criteria that allow us to reflect on situations, objects, etc. In my opinion, the terms pious or impious are of the same nature as good and evil, beautiful and ugly. For

me, the beautiful and the ugly are the basis of aesthetics, and the true and the false the basis of philosophy—to keep things simple. The pious and the impious are a dimension we cannot get beyond. And I believe we can no longer broach the questions of art, the questions of politics, the questions of mores without saying: this is pious, this is impious. Today it is something that has been swept aside… Precisely, the art of the twentieth century is an art that shows no pity, including toward the artist.

This was a century that backed away from nothing. It's no surprise that art, too, would have gone to extremes.

It's a century without pity. At first I put a question mark on "A Pitiless Art," then I took it back.

You don't seem to give contemporary art much of a chance. Did you show more pity for it in the second talk you gave? It is called "La Procédure silence" [Silent Procedure] and you gave this title to the entire book. But why silence, and in what way is silence a "procedure" that qualifies art?

The second part takes up again the question of pity by using the Silence of the Lambs as its theme. Today art is the silence of the lambs. I took the title from the war in Kosovo, NATO's war. Just read *The Strategy of Deception*: during the war in Kosovo decisions were made through a procedure of silence. Given that there were a dozen countries involved in the war, the American commander-in-chief of NATO presented the strategic targets, and the others weren't going to argue for three hours before bombing a bridge or the Chinese embassy, therefore silence—saying nothing amounts

to consent. I took up this expression because in my opinion the silence of art, the fact that the visual arts are silent, has become the equivalent of the Silence of the Lambs: a conditioning, a dumbness.

Visual arts obviously don't speak, so you can't literally reproach them for being silent. So I assume you're talking about another kind of silence. Remaining silent at a time of emergency. The visual arts have remained by the wayside as the entire culture is now being threatened by the extermination of space and the instantaneity of time. Instead of looking for ways of offsetting creatively the danger, art is looking away, or looking at itself, even nodding silently, colluding with the ongoing destruction.

Yes. Note that what I am saying mostly concerns art in the 80s-90s, that is to say the last twenty years. Everything we have talked about came to a stop in 1990. In my opinion, that is when things changed. And contrary to what people are saying now, they haven't come back together. Finita.

The 80s was the period neo-conceptual art allegedly started opposing media and advertising, turning it into an ironic art, a critique of commodity, a radical take on consumer culture. Richard Prince, Sherry Levine, Barbara Kruger, etc. were all busy reframing the Marlborough Man, rephotographing classical photos, rephrasing billboard clichés, reappropriating or recycling images. Gary Indiana, with a twinkle in his eye, called it "market art." It wasn't an oxymoron, it was what art in whatever form or shape has become. Any other kind of art by then was becoming impossible. As Jack Smith used to say (but, of course, he was a crazy man) "What is done with the art—is what gives it meaning… If it goes to support Uncle Fishhook, that's what it means." This is Uncle Fishhook time, and art is remaining silent, or making empty

gestures and statements against "powers-that-be" so that everybody can feel good about themselves. Art got reborn "critical" at a time criticality was no longer possible in an art world thoroughly bound for the market. Baudrillard had brilliantly demonstrated that fifteen years before in The Consumer Society,[9] *but the message never sunk in. No one drew conclusions from it. Even his "simulation" was taken as a critical stance. It was much worse. By then critique had stopped being the point and art, merely looking from new "angles" and quick-fixes, stopped trying to* reinvent itself *as art. No wonder critical gestures or critical signals were immediately given credibility and promoted to the status of great art. We're beyond good and evil. Art today is thriving because it is entirely besides the point. I guess this is what you had in mind by this silence.*

The infinite repetition of Duchamp and Warhol can be nothing else but academic art. I can't stand Warholism and Duchampism anymore. It's not a consecration of their modernity. On the contrary, it's the cessation of it. We've buried them.

Abstract art was a flight outward, pop art a flight inward, now there's nowhere to go except questioning the status *of art itself. We've reached a point where all the distinctions are being leveled, public and private, science and art, not to mention the distinction between sacred and profane.*

Art has become uncultivated. And that means profane art has somehow disappeared...

Uncultivated, I imagine, in the sense that cultivation is no longer possible.

Yes, the cultivation of the absence of cultivation. Myself, I used to love the Impressionists: they were the profane par excellence. In my day as a painter, I loved Cézanne, After all I am an architect. Now I would say it's Giacometti—but the more I think about it, the more I am sure that the Impressionists were the real revolutionaries.

You consider that the Impressionist revolution is still ahead of us?

They're the ones who opened the widow in the wall of official art, who exploded its sacred side, because official art is always a sacred art. There are plenty of great painters: Poussin painted marvelously, and Chardin, too; Corot is a good painter; but the Impressionists went off the deep end. They were the first relativists, the first to use Steiner's relativity, the light and all of it. I feel really close to them. They reintroduced a profane vision in all the official arts of the French Republic, not just in Saint-Sulpice art [bland religious art] but also in the painting of war. So, whether we're talking about Degas' or Monet's paintings—in my opinion, between Turner and Monet—we're dealing with a great revolution. The other revolution is Nihilism, Netchaiev, which announces totalitarianism through the October Revolution and through Fascism. In my view, you can't understand Impressionism without this nihilism. But today we have returned to Nihilism, to a nihilism of another kind.

We could call it consumerism, or the technological revolution.

Also, you can see the joy, you can see the feeling these painters had *before* the war—before the wars which we just discussed, before the

pitiless period. When you look at impressionist paintings, you say: this is incredible, this is different. What is this? The war had not yet happened. The Paris Commune was still too early.

Still, Impressionism already moved art towards decomposition.

Yes, but an analytical, conceptual deconstruction through optics, the laws of optics. Pointillism is pixels. Monet's series are already cinema, and in color too. When Kandinsky was a child—around twelve years old—the windmill series came to St. Petersburg, I believe. Kandinsky went there, and didn't see anything. He told his father: "What's that?" His father says: "I dunno." He didn't even recognize the windmills. And then Kandinsky said: "I went back because it was unusual—a painting that resembles nothing." It was like cinema, only in slow motion...

The Voice of Silence

In a nutshell, your opposition to the visual arts now is that things no longer appear; they disappear without even appearing.

They disappear to the point of being totally eliminated. And there we have the metaphysical dimension of the phenomenon. Contemporary art is contemporary with all of it: the loss of bodies, the deterritorialization and disembodiment Deleuze analyzed. That's all science does: eliminate. Eliminate bodies to the point... Well, that's the question: *to what point?*

The paradox is that art over the last twenty years has tremendously emphasized the body, as though it had to show it one more time before

it disappeared altogether. It wasn't a rediscovery, or a post-modern ressucitation, it was post-mortem before the fact. Freud also insisted on the symbolic power of the family at the time it started it disappearing. And Lacan merely doubled it up by casting the symbolic (and the Father) into language. There is a kind of...

...exhaustion.

Yes, but it's like a flush on the face of a consumptive. Sickness parading as health. There is an exacerbation of genders and sexual differences, not to mention of sex itself, just as they all are on their way out. We've never trumpeted so much crimes against humanity now that science can no longer tell what is and what is not human.

You have to have fireworks before the end, including the return of woman now that she is being eliminated. My greatest fear is that contemporary art has become an *optically correct* art, an art that can no longer permit interpretation.

To my mind art doesn't need interpretations. It has enough problems proving that it exists, that it still is legitimate. It's all voracious cannibalization, cross-references and cryptic connotations crying to be interpreted. It's become some kind of a con-game. Art history fronts for art, and often replaces it altogether. Everything is being historicized now that there is nothing left that's worth historicizing, and the same goes for the pollution of exhibitions, "Kassels of cards." Artists themselves become the historians of their own impossibility to survive their art. You anticipate the accident of science, but have you thought about an accident of art?

Yes, you bet.

Is it of the same order?

The accident of science induces the accident of knowledge, and art is a branch of knowledge, there's no question about it. Here we touch on something that interests me very much: the accident of knowledge. Through mathematical precision, through the experimental method, we have built a structure for science. But there are branches of knowledge without experimental methods, in the mathematical and scientific sense of the word—and that's what art is. Experimental science is the opposite of story telling, chimeras and myth. The rational position of science has gradually broken away from alchemy and magic. The experience, the experiment of art can't be mathematized, and so, yes, in my opinion, the accident is total. We are entering the period of the *total accident*: Everything has been damaged in the accident. Knowledge has been mortally maimed. This is not the apocalypse, forget about it. This is not catastrophic in the sense that everything is going to stop and we can finally cross over into the world beyond the world—not at all. No, everything that constitutes the world has experienced an accident, and this *without exception*. This colossal dimension of the accident surpasses us, and that's why I am so passionate about it.

The accident of art could be that art no longer has any reason to exist. This doesn't prevent it actually from growing exponentially more than it ever did before . Quite the contrary, the more it is defined by extrinsic conditions—by its position in the market place, in the art circuits, as part of the monstrous museographic inflation—the more it will have to look inward for justifications. Its existence is guaranteed to last ad

infinitum in some kind of suspended animation. No one would dare take off the plugs. It's too good for everyone to keep going in that happy comatose state of the arts. The end of art has been so much discussed everywhere (most brilliantly by my friend Arthur Danto) because it's already behind us. The end is becoming meaningless. We may be at the past-recovery stage. This brings us back to the silence of art.

This is no longer André Malraux's *The Voices of Silence*,[10] quite the opposite. I'm trying to explain that silence is a voice. I'm obviously paraphrasing Malraux, but mainly the *Old Testament*, especially Psalm 18: language without speech. God speaks without speech before the Prophets. Before Israel. God speaks in Creation: the sun speaks to the night, the night to the day. Clearly, the language without speech is the language of Creation. And Creation is nature. It's the sun, the beauty of the sea, etc., but it is also the creation of humanity. It's the silence of painting, the silence of the Impressionists. This silence was thwarted, and definitively in my opinion, by the arrival of the talkie—not by the arrival of cinema, but by the *talking* cinema. Painters were already doing shadow pantomime; the camera obscura was a camera with shadows that you would see almost photographically. Athanas Kircher's magic lantern was also something of a shadow. So, in my opinion, the cinematograph did nothing but continue painting by other means: the crank or electricity. On the other hand, when the image began to speak, to call out, we entered a world in which Plato's cave and the Sybil's cave were superimposed. What could the visual arts do against the birth of the audio-visible? Plato's cave is extraordinary, but no one talks about the Sibyl's cave. It just so happens that I was at Como, to the north of Naples, I went to the Sibyl's cave; it was the place that touched me the most, even more than Pompeii and Herculaneum.

And the Sibyl's cave, what do you think it is? It is a place that speaks and asks questions. It raises questions…

… to which there're no ready answers.

It doesn't give answers, but nowadays you do have answers...

...and no more questions.

So here we have an important revolution. Video images, infographic images, they are all *images that speak*. It's similar to what I said about the vision machine—giving sight to a machine without a gaze, sight without seeing, and giving speech to an image without humans: we are faced here with developments that can only disturb art's voices of silence for good. And beyond, the voices of silence of every kind, and whatever they are. Never again will there be a sunset, never again will we enjoy the beauty of the mountains. Do you remember the beginning of that novel by William Gibson: "The sky was the color of TV." That's the only thing I remember of it, but it's perfect pitch.

So the talkie is a hybrid, a monster. A cinema that is fatally maimed because it relies on verbal crutches.

It's the end of art, yes. Afterwards it was just *bricolage*. In 1927, the jazz singer Al Johnson, who was white, painted himself in blackface. And the first word he said was: "Hello baby, hello Mom." It's really extraordinary. Hi Mom!

A new art was being born. It was a farewell to silence.

They should remake this film, or show it again. There were others, but this one sets the standard.

Making Images Speak

So this is the second part of your book. It deals with the impact of the talkies on art.

Yes, on art. It's an impact which has been rather neglected, in fact totally overlooked. The impact of silent film on art is banal. Curiously enough, no one has really discussed the impact of the *talking* film on art, including the best critics. Not even Gilles Deleuze in his books on cinema.

There has been, of course, many discussions about film's impact on politics. The talkies not only killed the expressiveness of the body, it also silenced the audience by erecting linguistic frontiers between nations. Jean-Jacques Abrahams, "the man with a tape-recorder" celebrated by Jean-Paul Sartre in Les Temps Modernes, *brilliantly defended this thesis in a delirious essay, "Fuck the Talkies."[11] Silent film, he wrote, used to speak to everyone. It raised the possibility for mankind of finally "rediscovering in itself a common language, the principle for the unification of humanity." And the talkie shouted it down to the ground. It triggered the unspeakable devastations of WWII. Hitler's film propaganda, the muting of the masses, started just after the talkie began. But yes, I don't recall any discussion of its effect on the visual arts. People generally assume that visual arts don't talk, hence the need for interpretations, commentaries, theory to supplement them. Making art must be a dumb activity...*

There are a ton of books which have been written on the cinema as setting the image in motion, animating it at the expense of the fixed image; but in my opinion, the denaturing effect of talking cinema has a far greater responsibility for the terrorism, the upheaval, the disaster of contemporary art than cinematograph itself.

Artaud raged about the effect of the voice on film. He saw it as the negation of cinema, and he quickly dropped it for the theater. Actually most of the features of his theater of cruelty come straight from his previous involvement with silent film.

The talking cinema happens from 1927 to 1929. This was still the great critical period in the United States.

And you believe that the talkies could be held responsible for ending that period more so than the 1929 crash, as Abrahams also alleges?

Yes, by synchronizing vision and audition, just the way action and reaction recently have been coupled in a process of simultaneous *interaction* through "tele-action."

So there's no more need for the audience to say anything, or even think for themselves, let alone dissent. The talkie does it all for them. Actually it doesn't even need an audience. It is one onto itself.

Yes, it's a ventriloquist's art.

What's left is silence, but of another kind. It is not conducive to reflection or contemplation. It's a silence filled with empty words.

It's "keep your mouth shut"... As George Orwell said, the screen satisfies in advance every one of our desires...

It's Mom and her autistic child. Silence used to scream, the talkies silenced it.

Yes. First Munch's scream and then Beuys' silence. If someone ever worked on silence, and deliberately so, it's our Luftwaffe pilot with his fedora. German expressionists of the 1920s and 1930s antici-pated mass communication because they tried to make images speak like the screen. You can't make walls speak without endan-gering frescoes, or painting. When art starts shouting its fear or its hatred, there can be no more dialogue or questioning. I touched on all that in the book, and of course I also discuss the aftermath of the great massacres, Cambodia, Rwanda, etc.

You could well see conceptual art as a way of preserving this silence of art, but at the expense of painting. In conceptual art the idea is more important than the way it looks, and it may be discovered intuitively rather than being articulated. The form this idea takes is not really essential, sometimes a mere approximation. Planning and execution are what makes the art. You can see that, for instance, in Sol Levitt's work.

In my view, conceptual art was an attempt to bring art closer to philosophy. It's true that art and philosophy have always been close, you can't separate them. Marcel Duchamp is more a philosopher than a painter, even if the "Nude" is a beautiful thing, independently of everything they say about it. The *Big Glass* is really extraordinary. I wouldn't say as much for many of the other things he did.

Conceptual artists viewed their work differently than philosophers would, but it is true that conceptual art had philosophical implications. Joseph Kosuth, who invented it, definitively conceived it that way.

Yes, I believe something is really at stake in this aesthetics of disappearance. Conceptual art tried to transfer the silence of art into the language of the concept. What spoke was the concept, a speechless concept, speaking in place of speech. There was something extraordinary there, something that went well with our research. Conceptual art was one moment, a really great moment. Now it's over. Now anything goes.

Conceptual art was poor in means. It often was a non-object art that resisted, often successfully, to the enticement of the art market.

It was a poor art, but of a different poverty than *arte povera*.

Now even diagrams, notes and sheets of paper from conceptual artists like Dan Graham, let alone Fluxus, have become quite valuable as well. Conceptual art cultivated the art of disappearance, just like Mallarmé...

Just like the great modern architecture. An architect like Tadao Ando, for example, independently of his Japanese culture, had a conceptual dimension, and I could cite others. Now they're all becoming manufacturers. Frank Gehry is no longer conceptual art; we're back to formalism...

Yes, I agree. Conceptual art is mostly devoid of formalistic or aesthetic content.

It's speech, the concept is speech. I want to say: the way to resist the talking image is the conceptual image; the concept speaks. It speaks silently. But loud enough for us to hear it, whereas I see many painters, including narrative figuration, where you don't hear anything. The long piece I wrote on Peter Klasen, a beautiful book, came out one year before *Art and Fear*, so the two are connected. It's called *Impact Inspections*.

The Face of the Figureless

Klasen is a German artist, a neo-realist painter.

He was born in Lubeck, and he was in Lubeck during the bombing.

He was a victim, you wrote, of the war of time, of this century which has seen the ruins of cities, Germany's year zero.

Peter Kasen witnessed the conflagration in the cathedral where the Virgin of Membling disappeared. He's someone who lived through the war.

Klasen's art, you said, is the art of the accident. But there's no outward accident there. At least nothing that one could identify as an accident. His paintings seem caught in slow motion. They are about smooth, frozen machines, or present cutups of technological equipment. He breaks it down so we see it for what it is. It's like pulling a gun apart before using it. The impact can only be inferred from the display of the parts.

He simply focuses on the technological object. What interested me is that he did portraits of techniques, technological still-lives.

When he paints a grid, or a reinforced door with the words: "Warning: High Voltage," he makes us see the face of the technological *dasein*.

There's no distance in the image. It's completely flat.

Yes. Like a fly against the window. Splat! What I like in his work is the large screens. They're like "instrument panels" of a machine with warning lights studding the control panels. His images are stereotopical and iconoclastic. The threat is omnipresent in his work.

You consider his work a deliberate act of resistance to the delirium of acceleration. It's everything but expressionistic, and yet the violence can be felt everywhere. Klasen reveals the cold-bloodedness of technology through an excess of cold-bloodedness. It's a technological nature morte, death made present through the ominous stillness of the machine. His work seems to be some kind of visual equivalent to what you're trying to suggest on a more theoretical level. You often offer striking quotes in lieu of analyses. His work is just one big quote for what you're trying to suggest.

Klasen reveals the face of technical beings. The face of the figureless. It's the *Silence of the Machine*.

There's nothing human in it, nor inhuman either. It's just there, it doesn't need you. The surface becomes kind of abstract. It's not painting, more like a photograph. But it isn't one either.

No. He has this airbrush technique. It's extraordinary. He borrowed the aerosol from the world of advertising. When I was a

child, I also painted advertisements and film posters for Giraudi, then a big paint firm in Paris, using the same techniques. He paints like a publicist—but it's not advertising. In my opinion he diverted the figurative through advertising. So, on the one hand we have pop art, and on the other advertising techniques. He has a foot in each camp.

He certainly didn't celebrate consumer objects, as pop artists did. He was consumed by technology. It doesn't address anyone. He refrains from touching the canvas, as if there was something diseased in what he describes, something invisible and deadly, like radiations. His paintings radiate fear. He uses airbrush as if to remain at a safe distance. No colored pigments either. It's all monochrome. There's a sinister feeling of imminence. *Something is about to happen. It's stillness in the eye of a cyclone. And this kind of eye doesn't see. It engulfs everything.*

I couldn't have written that about any other painter. On the other hand I don't think it is an innovative text. I try as best I can to stick to the career of this man whose work I appreciated, but it also corresponds to another period. I refer to some contemporary issues in it, but what is happening right now really is beyond its scope. The book has had some commercial success and the publisher asked me to write another one on Poliakoff. "Are you familiar with Poliakoff?" he asked. And I said, "I have one of his works at home." But I refused. I have nothing to say about Poliakoff, except that I love his work. But Klasen, I am totally wrapped up in it. Not about everything he did either. In his latest paintings there are neons with cries, words inside. I think it's a mistake to make them speak, to subtitle paintings.

So you're not necessarily against painting, as people generally assume you are.

It's an aberration to say such a thing. With Klasen, it's the first time I wrote on a painter. But I've been a painter myself, as you know. I did photography for ten years, so you could say that art is in my life. You could put Peter Klasen with Paolo Uccello. These screens have such an evocative power. There's something so cold-blooded in them.

It has a clinical look. It opens up technology to exhibit what's inside. It's like an autopsy. The autopsy of an entire culture.

This cold-blooded gaze used to belong to doctors and nurses. They used to be called "the men of art" before it belonged to artists. Prior to the modern period, surgeons, all those researching on corpses, including painters like Leonardo da Vinci, didn't brag about it though. It wasn't a sign of professionalism as it is now. If they happened to mention it in their notebooks, but they didn't make it sound heroic. They even showed some remorse.

You have criticized cinema because it talks and the visual arts because they're not silent enough. Now we're talking about the body of technology replacing the human body. You've always been preoccupied with the body and the possibility of preserving it from the encroachment of technology. The kind of architecture you devised in the early 1960s, the "oblique principle," was essentially trying to do that. It was meant to turn human dwellings into some kind of permanent training ground for the body.[12] Buildings would be entirely made of inclined planes that required a special effort, and would make sure that we would remain

conscious of our concrete corporeal existence through obstacles in everyday life. Consumerism was beginning to make everything abstract and insubstantial—merely comparing signs—and you were rushing in emergency remedial features. The Situationists started drifting through the city; you built up resistance at home. Oblique architecture was a soft version of Artaud's theater of cruelty, a modernist strategy meant to counter people's increasing absorption in a universe of signs and images. A spiritual antidote to the Society of the Spectacle. Your post-1968 realization that speed was the main culprit turned you towards physics and theory. You analyzed the dissipation of space in instantaneity and the reversion of live time into inertia. Most people, bedazzled by your dizzying anticipations, didn't realize that the presence of the body remains at the center of your preoccupations. And this certainly holds true for what you think about art.

I still very much believe in arts that involve the body, dance, theatre, etc. That's why I think the plastic arts have gone terribly astray, not to call them totally obsolete. I believe the line of resistance no longer runs through them; it moves through dance, theatre, land art, which need a place and work with bodies. I gave up on painting a long time ago.

With you the body always comes first. That's the root of your attack on contemporary art.

I can't be myself part-time, by half-measures. I just can't. It's not easy to say it, but I love bodies, and bodies are always painful. They tell me the body is pleasure, and I say: you must be joking! Get old and you'll see. Bodies are pain, and pain is love. You can't separate them. I can't hide the fact that I converted to Christianity, so something in

me is attracted to the sinner. For me, a person only exists through his flaws. I have always been fascinated by assassins, prostitutes, etc. I feel like I'm one of them, because if you get rid of original sin, there's nothing left. You have no more humanity. My Christianity is connected to that. It's Jeremiah, not Isaiah.

The Arts of Disappearance

You said that resistance runs through the arts of representation. But dance and theatre require presence and immediacy.

I mean that the latest contemporary art is a presentation rather than a representation. Representation has a cult dimension, so to speak. They are liturgical ceremonies. That's why dance is so important. But today dance is no longer dance, so what is it? A presentation that has no other value than in the moment. It doesn't seek to endure. It doesn't deal with the past, since we broke with it, nor the future.

Modern dancers tried to break away from the classical ballet repertory of movements driven by a story or structured by a musical score. It was the breakthrough in dance and music that made New York so exciting in the 70s, from the Judson Church, Yvonne Rainer, all the way to "contact impro" and the combined performances of Merce Cunningham and John Cage. They got rid of a rigid vocabulary that didn't give the body a chance to reinvent itself in real time without being subjected to any contrived narrativity.

Exactly. These are arts in the present tense, arts in real time. We're coming back to the "live." It's live art, and the only thing that

counts is its instantaneity—its "instantaneism," as they say nowadays. This goes hand in hand with speed.

Does it really? In modern dance the body is continually present on the stage. It's a total immersion in a singular experience, with no external crutches to peg it on. Granted, it is difficult to memorize or remember because the disjointed series of movements create their own logic along the way independently of the music itself. Chance connections prevail. But Artaud may have perceived the Balinese dancers in that way, as rigorous algebraic ideograms unfolding on the stage, not like a rush of images past the screen. He didn't know the script, and there was one.

It's a spectacle. In my opinion, all art today is a spectacle. Whether dance, exhibitions, theatre, video-installations, or certain kinds of presentations like those sponsored by Satchi, it's only performances.

Performance is contemporary art insofar as you can't repeat it. It's rigorous, constantly inventing its own logic. It stands all by itself and this is the beauty of it.

I won't deny that. But, remember, I say: *contemporary with what?* It's contemporary in the sense that it isn't modern, or ancient, or futurist: it's *of the moment*. But it can only disappear in the shrinking of instantaneity, because the instant is constantly being reduced. We know it all too well: from microseconds now we've reached nanoseconds. So, in some way, the instant is what does not last, what disappears. A fixed moment would make no sense...

I could argue just the reverse: that it is an attempt to extract from instantaneity a form capable of preserving the singularity of its existence, the

way buildings in California integrate structural mobility in order to absorb devastating earthquakes. It's very insightful, though, that you would make modern dance part of the overall "real time" electronic environment. This wouldn't have crossed my mind since they seem to belong to such different series. And yet dance participates in its own right to what the Situationists used to condemn as the "decomposition" or auto-destruction of the arts. But they may also be more apt to resist the powerful shake-up of all the codes. But it is true that Cunningham felt the need to record his dances on video to prevent them from disappearing altogether. Artaud insisted on the algebraic character of the Balinese dance, the mathematical rigor of the performance. He knew it was steeped in a powerful tradition, even if he himself didn't have access to it. These kinds of traditions have mostly vanished by now in our culture and we've got to experiment with new codes in order to find what forms could still hold.

Choreography needs scenography, as does theatre, and this is fundamental. The *in situ*, the *hic et nunc* are everywhere disappearing, and this is leading to the elimination of the visual arts of representation while giving back to the body, once again, its power. I don't see how the failure of the visual arts can be overcome. On the other hand, there has been a transfusion of the visual arts in the corporeal arts...

But this also means the spread of "body art"...

Oh yes, with the frightening risk it entails. The continual inflation of super-violence in German expressionism, and then the practices of body-art, like those of Orlan and my friend Stelarc. I was very proud that Stelarc came when I was made Emeritus Professor at the Ecole

Spéciale d'Architecture in Paris. This man is incredibly intelligent. And at the same time our ideas are opposed in any possible way.

Stelarc is a futurist.

Yes, Stelarc is a futurist. Marinetti said: man must be nourished on electricity, not just protein. Stelarc and others have this idea that to survive humanity has to mutate, but mutate voluntarily by its own means. This, I think, is a delirium of interpretation on the nature of earth, which is one of the big questions of ecology. Ecology has not yet touched on it. It hasn't made much progress there.

You find a similar idea in William Burroughs. The idea that the human species is in a state of neoteny and is not biologically designed to remain as it is now. And he envisaged the possibility of an "astral body," a lighter body meant to fulfill our spiritual destiny in space.[13] In the beginning art was premonitory, it was prophetic. Now, the futurists were also prophets in their own way. They anticipated the technological leap we are experiencing now. The same goes for Stelarc and Orlan, with whom you seem to strongly disagree. Orlan's "performance-interventions" are silent. And her videos of surgical operations often compel the audience to close their eyes. There's something obviously cruel and ritualistic about them, her "operating theatres" owe a lot to artaud's theatre of cruelty. Her work on flesh— she calls it "carnal art"—deliberately uses new technologies (hybrid images of Greek goddesses produced by morphing software) to call into question the status of the body in our culture. She went as far as inserting implants in her temples, or having a very large nose constructed surgically : these are questions addressed to the fragility of the body, and to the future of the human species.

Many years before her physical transformations, Orlan invited me to her studio—it was behind the La Coupole brasserie in Montparnasse—to show me some photo-montages and installations (in which, as if by accident, she figured the Virgin, Madonna; and they were baroque too). Before I left she told me she was planning to have some aesthetic surgery done on herself. And she asked me, "What do you think?" Obviously I wasn't in favor of it. I didn't think that putting her own physical integrity at risk was such a good idea, but she insisted that artists have the freedom of expression. "Listen, Orlan," I said, "you're free to do whatever you want, even commit suicide. Anyone can commit suicide, all it takes is a window. But *I* am not free to tell you, 'Go ahead, jump.' You see what I mean?" She didn't get it. That's intolerance. I met a professor of contemporary art history who told me, "When I get to a class on self-mutilation, I'm at a loss to teach it…" Can he tell his students, "Take this razor-blade and go do your homework?"

I have taught the Marquis de Sade occasionally and the class didn't turn into an orgy. De Sade was an enlightenment philosopher, except that he used fiction to exterminate any certainty about mores. I would say he was a great satirist, like Swift. Do people eat their own babies after reading Swift? Now the Actionists are an entirely different story. There's no distance whatsoever, and no humor involved in their orgies. They invite repulsion, which is a category of the sacred. Repulsion goes together with attraction. Hasn't shedding blood or tampering with one's body always been part of sacrifice? Originally art had to do with the sacred. And it seems obvious to me that Orlan, like you, is steeped in the Christian tradition. Self-flagellations and martyrdom were highly valorized among early Christians, and celebrated by the Church for centuries after that, not without a certain relish for cruelty.…

You can find violent practices in certain religions—I'm thinking of the mutilation of women's feet in China—but these practices were still connected to precise rituals. I believe there have been three periods of art. At the beginning, and it can hardly be denied, art was "sacred," in quotation marks. Sacred art includes cave painting or animism as well as the Sistine Chapel. Then we went from the sacred body—whatever body it is: saint, Messiah, angel, etc.—to the profane body. And today we are beginning the third stage in which we return to the profane body.

One symptom of this return was the extraordinary interest accorded to bodies in the visual arts in the 1980s—even when wrapped up in an elaborate ideological or psychoanalytical critique. It was much less a rediscovery of the body than a sort of farewell to any permanence it once used to have. Now the body is not dismembered exoscopically in psychotic dreams, fragmentation has become a new reality and the body a mere logo game: changing parts that no longer seem to make up a whole. Dead bodies, in that respect, seem to hold together much better. They have taken over some of the attributes living bodies had to relinquish. This may have been an important factor in the scandal that surrounded the exhibition "Korperwelten" [The Worlds of Bodies] *in Mannhein in 1997.*

It was held in the "Museum of Work," which was a little much, don't you think? Mannheim is in Germany.

Dr. Günther von Hagens, the German anatomist who "prepared" the corpses for some kind of posthumous performance, was accused at first of being a "grave robber." But it may be the living, in fact, who had robbed dead bodies for at least a century by making them disappear

publicly. Today it is only fair that the dead would return from death alive. During the Baroque period, they had no compunction about displaying dead bodies anyway and it was both artistic and clinical. People were genuinely interested in what the inside of their bodies looked like.

Mantegna, Paolo Uccello, the perspectivists: it was already science...

And science which questioned itself in the best of cases. Science was coming out of the body in the open, as is happening right now. People like Günther von Hagens are just making it in a more spectacular way. Since that exhibition, millions of people all over the world hurried to see recapped cadavers perform some kind of still art, or flesh sculptures. Why? Till recently we thought we had lost the experience of death. Now that we no longer know what life is, or where it stops, we may feel the need to put death on display. Thanks to plastification—the substitution under pressure of fat in tissue by silicone plastic—and an uninhibited choreography, the dead become actors in a living drama of the flesh. Where we expected some creepy nature morte, what we have is "authentic" tableaux vivants. Do you believe the profane body could reclaim something of its sacred status through similar practices?

Not really. The profane body reclaims the sacred through the *Homo Sacer* and the sacrifice. What was grand in sacred art, whatever the religion, becomes monstrous in profane art. But it is a sacred art. The return of satanic cults among children is a return to the sacred. The sacred in reverse, but sacred nonetheless.

What would characterize art then, according to you?

What characterizes art is creation. They can say what they like, but here we come back to pride, to the Bible. There's a demiurgic impulse in art. Sacred art *idealized* it. What is sacred art? It makes the demiurgic impulse official—taking oneself for God. The demiurgic impulse today is no longer sacred, it is profane. And ultimately the demiurgic impulse has been profaned. The problem is no longer the profane body, it is the body which has been profaned. In my opinion, the demiurgic impulse of sacred art has moved into genetic art, and into other sectors as well. And it means going *all the way*. It's thumbs down for the gladiator. We're finding ourselves face to face with a world that has been forgotten, and we no longer have any idea what it means. We'll have to read Augustine's *Confessions* again. He was a big fan of the games at first, and then he recoiled in horror at the sight of the atrocities. I don't want to say more. I don't have a theory of art, and have no desire to invent one.

The Accident of Art

The Accident of Art

Failure and Accident □ The Vision Machine □ Retinal and Optical
□ The Eyes' Newspeak □ Globalization without Vision □
Wrestling with the Machines □ The Pollution of Art

Condemning the "modernist" avant-garde is a venerable tradition
among old school Marxists. In his Everyday Life in the Modern
World,[1] *published in 1946, Henri Lefebvre took Baudelaire and the*
Surrealists to task, accusing them of showing contempt for the common
people. More recently, Eric J. Hobsbawm, the renowned Marxist histo-
rian, went still further in his Behind the Times: The Decline and Fall
of the Twentieth Century Avant-Garde.[2] *He singled out the visual arts*
for having "patently failed" to adapt to the era of mechanical reproduc-
tion. "The 'modernity'," he asserted, " lay in the changing times, not in
the arts which tried to express them." Exhausted by their battle against
technological obsolescence, art turned out to be the real victim of this
failure. The real revolution in the 20th-century arts was achieved
instead "by the combined logic of technology and the mass market,
that is to say the democratization of aesthetic consumption... Disney's
animations, however inferior to the austere beauty of Mondrian, were
both more revolutionary than oil-painting and better at passing on

their message. Advertisement and movies... converted the masses to daring innovations in visual perception, which left the revolutionaries of the easel far behind, isolated and largely irrelevant." You pointed out some convergences between this judgment of modernity Hobsbawm made and your own critique of contemporary art. What are they?

Failure and Accident

What I like in this text is that it illustrates in some way what I myself developed in two books: *The Vision Machine* and *The Art of the Motor.*[3] The motorization of the image, before the arrival of the talkie, the image that talks (as I wrote in *Art and Fear*, first the image is motorized and then it talks) demonstrates that the static arts, the "plastic" arts—plastic is synonymous with static—including fresco, sculpture, or painting, have been horribly impacted. Hobsbawm talks about the failure of the visual arts, and I totally agree with him. It is not failure in the sense that the visual arts are bound to disappear in favor of a super-TV or superior infographic images. But something has been lost irrevocably in the art of the motor, in the art of motors, the electric motor of the camera, the electric motor of the video camera, and obviously the computer's motor of logical inference or the internet's search engine. The art of the motor has surpassed the static nature of the plastic arts. Motorization is not simply the motorization of society (I will merely point out that the 30s and 40s were characterized by the motorization of forces, including the *Blitzkrieg*, which allowed the *Reich* to rise up; this is Futurism); motorization processes art through photography and cinema, and today, of course, through electronics, the computers, the delirium of synthetic images and virtual reality. So what I like in Hobsbawm is that he has the guts

to say that there has been a failure in the visual arts. It is true that van Gogh goes quite far, but film has gone still farther with regard to expressionism and what I would call the appearance of the real.

Hobsbawm declared modernity to be a failure in so far as it aspired to a continuous progress comparable to what science and technology can offer: the idea that the expression of each period would be superior to what preceded it. When you say that the motorized arts have gone farther than the plastic arts, it seems to be paradoxically a "modernist" argument that you are turning against the visual arts.

No, I am saying that the very nature of the plastic arts has been affected. The static is a necessity of movement. Let me explain. For a wheel to turn, there must be a hub that does not turn. All the way up to the motorization of the image, and up to the "audio-visible," the talkie, there was a fixed point, a point of reference in the civilization, in the static nature of the plastic arts, the architectonic arts, including static prints, painting, engraving, etc., through the modern movement. The fixed point was the static picture, and it was silence. Because the static and silence go together: silence is to sound what the static is to movement. Now, something fatal has happened to the plastic arts, and it has gone unnoticed. What I like about Hobsbawm is that he reveals a failure. He dares to say so. I am saying it, too. It doesn't mean that what they're doing in cinema today is terrible, just that something has been lost.

Hobsbawm is eager to enlist the visual arts in the construction of a better society, but he defines the aesthetics of this "machine age" by a marriage between Henry Ford's cars and Le Corbusier's "machines for living." The Ford assembly-lines turned out to be a living hell for

industrial workers and Le Corbusier's Cité Radieuse became the prototype for the working-class ghetto-like projects built by the millions in Europe in the 50s and 60s, and eventually passed on to the Muslim immigrants in France. Not a great feat really. Liberal humanism can just go so far. Hobsbawm also presents the map of the London underground system as the most original work of avant-garde art in Britain, because it is an effective way of presenting information. That's a cute conceit, but he seems to take it quite seriously. No wonder he praised Dada for wanting "to destroy art together with the bourgeoisie." The Dada wanted to destroy art, but they wanted to do it as artists. *It is obvious that Hobsbawm wishes both art and the bourgeoisie dead. I don't think you do.*

Hobsbawm has a Marxist dimension, which I don't share. However, in this case, we're in agreement. In my opinion, something has been played out in this loss: the arts of the 20th century are a disaster, and they don't acknowledge it. They continue to walk on nothing, as characters do in cartoons, and then they suddenly look down and fall. Right now, they are beginning to look under their feet, and they realize there's nothing there. What I like in Hobsbawn is that he has the guts to say what I say in *Art and Fear*: there is a catastrophe of art; the plastic arts, as silent and static, have experienced a total accident. To acknowledge today that there is failure—not an end, nothing is finished—is to recognize that there is hope. My logic here, don't forget, is also the logic of Augustine: as long as there is anxiety, there is hope. The phrase is my own. He says: "When there is no more anxiety, there is no more hope." When people like Hobsbawm or myself say: "There has been a failure," then somehow hope becomes a possibility. Once again a real question, a truly real question, can be raised.

But this question will not necessarily be framed in terms of visual art or pictorial art. Or even in terms of art at all.

I have nothing to say about that. I don't feel like playing the prophet.

But the situation may be calling for one. Hobsbawm estimates that there's double failure: first, visual art failed to reach the masses (whatever that means at this point); and second, art failed to change the world. Actually art is now reaching a far wider audience, but only at the cost of its soul. It has become a part of the consumer society, and functions as a sign of cultural privilege among many other signs. The arts have been consumed by society the same way the masses have. In that sense the visual arts succeeded all too well.

Think of this sentence from Malevich that Hobsbawm cites: "Constructivism is the socialism of the image." And I feel like saying: today liberalism is the capitalism of the image. *Loft Story,*[4] advertising, etc., are capitalism of the image. Something that I called the "optically correct" is at stake: the failure of the visual arts leaves open the possibility of the *optical correction* of the world. By whom? By machines and businessmen, who happen to know how to work together quite well. We are no longer faced with the possibility of the politically correct—it's an old ideology, it's old hat by now—but with the possibility of the optically correct. Optics itself enters the game of fascination. Optics, and not the content of the image, but optics itself—the procedure of the revelation of forms through the visible and the audio-visible, since they're now linked together. And, of course, virtual reality goes even farther, since all the senses are involved, except for taste.

But you don't think it may be asking too much of art, in whatever form, to change the world? After all, Constructivism itself did not change it...

No, no, not at all.

...no more than it changed socialism either.

Neither of us, Hobsbaum or myself, ask art to be revolutionary instead of men. What I am saying is simply that *the very success of the arts has been a failure.* Hobsbawn says that Walt Disney is a lot worse than Monet, but Disney won. Even the success of Monet and Cézanne has not prevented pictorial visual art from failing. The same goes for film. He says that a film goes farther than a painting in its expressionism.

Can we really compare the different arts?

He's the one comparing them. I don't mean that the arts of the 20th and the 19th centuries have not been good, but that even their success has been a failure with respect to the revolution of the motor, with respect to motorization, with respect to the arts of the motor and the vision machine.

The Vision Machine

The vision machine certainly has disengaged from painting, but that doesn't necessarily mean that painting as such is being eliminated.

We are not talking about elimination, but about failure. The problem is to recognize that there is a failure, not that one kind of

optics has been substituted for another. There is an optics which came from the Quatrocento and from the wall painters and spread throughout all the arts, and throughout every continent. Just as much through Negro Art as through frescoes, etc. And this is what has failed.

Early on in the century, artists questioned perspective in a radical way. There was the cubist fragmentation of perception, the introduction of time and speed with Futurism, and before that the explosion of light with the Impressionists, which we talked about earlier. There were all sorts of attempts to maintain the impact of the visual arts in a world that was rapidly changing. So I wonder whether this failure and condemnation...

Failure is not a condemnation! It's not the same thing. Failure is failure. Failure is an accident: art has tripped on the rug. In any case you should not forget my logic of failure, my logic of the *accident*. In my view, the accident is positive. Why? Because it reveals something important that we would not otherwise be able to perceive. In this respect, it is a profane miracle.

Like Benjamin's profane illumination for the Surrealists?

What is a miracle? It is a gift brought before the eyes so that one may believe, so that there could be some superior hope. Granted, the accident, in a certain way, is a miracle in reverse. It reveals something absolutely necessary to knowledge. If there were no accident, we could not even begin to imagine the industrial revolution or the revolution in transportation, etc. So please don't confuse the term failure...

But you used the term "failure" and not accident.

I am just borrowing Hobsbawm's term. Rather, my logic is that the vision machine and the motor have triggered an accident of the arts in the 20th century. And they have not learned from it. On the contrary, they have profited from it. They are on top of the world. When you look at Christie's or Sotheby's auction prices, Rembrandt comes after Warhol, Monet after Duchamp.

In July, 2001, Monet's "Haystacks, Last Rays of the Sun" was sold for $14 million at Sotheby's in London. It was the highest price ever paid for a painting in this famous series.

It's just a big bluff, obviously. They have masked the failure or the accident with commercial success.

I'm afraid it's all beyond success or failure, and beyond art itself. It's pure speculation. No wonder it affects everything that has to do with art. However hard I try, I myself find it more and more difficult to separate art from the market, which has become its finality and destination. Many artists have creative ideas, even take real chances, but the ecstasy of value is now preempting everything.

You will notice that I don't talk about the market; I cited market value as an example. To use an ethical term, I would say that the *pride* of contemporary art has masked its failure, and its weakness. You have the inflation of the dealers, the immense wealth of the galleries and artists, the delirious prices of contemporary painters, but at the same time it's a facade, and it's all going to fall. Either there is no accident, or there is an accident, and this accident is

going to provoke, has already provoked a reversal of tendencies and values.

Art has become some sort of black hole. The pull, the glamour, the giddiness of it all is too strong for anyone to resist. And at the same time it's just crude business deals and shady calculations. It's become no different than anything else.

And that's where we are, we're right in the middle of it.

If we are talking about that kind of "failure," I would certainly agree with you. And so would as well I'm sure, everyone involved in the art world today, whether they admit it openly or not. Art is being instrumentalized beyond recognition. It's becoming ancillary to capitalism. In the 80s, artists played with the post-modern idea of "the death of the author." It didn't really dawn on them that it had arrived, that they were all already post-mortem. In spite of everything, they believed they could still be some kind of cultural heroes. But there is no more artist life, only another regimented profession.[5] I am sure, though, that you had something more specific in mind, something which has to do not just with the situation of the arts in general, but with the nature of the image itself.

That's correct. Behind the vision machine and the failure of the plastic arts, I believe there is a *substitution.* It has to do with digital technology. Digital technology is a filter that is going to modify perception by means of a generalized morphing, and this in real time. We are faced with something which is more than the failure of the traditional static arts, both visual and plastic: we are faced with *the failure of the analogical in favor of calculation and the numerology of*

the image. Every sensation is going to be digitized or digitalized. We are faced with the reconstruction of the phenomenology of perception according to the machine. The vision machine is not simply the camera that replaces Monet's eye—"An eye, but what an eye!" said Clémenceau—no, now it's a machine that's reconstructing sensations pixel by pixel and bits by bits. Not just visual or auditory sensations, the audio-visible, but also olfactory sensations, tactile sensations. We are faced with a reconstruction of the *sensas.*

What do you mean exactly by "sensas"—sensations?

"Sensas" are the basis of sensations, the way we say psyche, etc. And here lies the failure of art. Because art was the interpreter between an "eye," or some analagous sense, and whatever else.

The accident of art is already what led Duchamp to invent non-retinal art. He preempted digital technology conceptually.

But I could not say this without the filter. Without digital technology I could not go so far as to speak of an accident of the plastic arts. Digital technology is like the icing on the cake. It is the completion of everything—in the same way the genetic bomb closes the system of the three bombs.

The other two, let me add, being the atomic bomb and the information bomb (or computer technology).[6]

That's right. The information bomb is the bomb of science. Thanks to information technology, thanks to calculation, we are now replacing the *sensas.*

We're becoming a bit more inhuman, let's say cyborgs in our own right. But even Cyclops had an eye, "and what an eye...," Homer would say. Now the machine is blinding us and we don't even notice it.

We don't even realize what the end of the analogical is. We can't even imagine what it is. It is not even a problem of metaphor. It is a problem of representation: events, sensations, and perceptions are put at a distance through an individual. The machine, as far as it is concerned, presents something through a calculation.

Machines don't represent anything anymore, they create their own kind of presence.

Yes. What machines do is *present*, since they reconstruct everything, every sensation. So, here we are, faced with an unprecedented event. Mind you, when I say this I don't mean that we should go back to engraving. I don't even think the phrase "go back" is valid. I am saying: this is a *catastrophic* event, and if we don't take it into account, every hope will be lost.

Retinal and Optical

Other substitutions or disjunctions already happened in the visual arts. Non-retinal art became conceptual. Conceptual art seized on ideas that were implemented in any material whatsoever, even language (Joseph Kosuth). It was no longer an art of representation, it was thought wrestling with perception. The mental act presided over every visual creation of form.

That was a philosophical divergence. In fact, during the period of the audio-visible—I am fond of this expression—the plastic arts believed that they could make a comeback to philosophy. Behind conceptual art, there is a confusion between painting and philosophy. It's not a bad confusion, it's abstract art. It is the same with Gilles Deleuze, and with conceptual philosophy. All our philosophers are conceptual philosophers.

Yes, but these artists were conceptual philosophers of the visual.

They go together. I mean, it is no accident if philosophers and painters had their period of glory together. All the philosophers have discussed painters, whether it is Gilles Deleuze on Francis Bacon, or Jacques Derrida on Adami. Jean-François Lyotard was nuts about pictorial art. Something happened there which is an event as it happens in science, and an accident of knowledge itself. Because the arts are some kind of knowledge, I think we agree on that. Philosophy and mathematics are not the only ones... The conceptual period is an interesting period, and in my opinion it already translates the failure of the visual arts.

Art is a creation of knowledge, just like concepts.

Yes, a creation of knowledge. I've always said that Duchamp was a philosopher who painted. Why should a philosopher be obliged to write treatises? I know some philosophers who make films. Robert Bresson was a philosopher who made movies, and one could say as much of Jean-Luc Godard. So, what is philosophy? I am in a good position to talk about it: I am not a philosopher but I do philosophy through what I write...

The visual arts made a real effort to break away from representation. Minimalist art explored the limits of visual art, turning their attention to the very nature of the material that constituted it. Conceptual art focused on the working of the mind. Interestingly enough, these arts were not meant for the market, and dealers perfectly understood it. When I arrived in New York, in the early 70s, gallerists bluntly told me that they weren't buying any of it. (Actually they must regret it now. Every piece of paper from that period is now worth a fortune.) They were waiting for the return of painting, which paradoxically made a comeback in the United States via Europe, with German and Italian neo-expressionist painting. At about the same time galleries began to proliferate, museums to expand exponentially like the obese. Then hordes of young artists started rushing in… Art became a legitimate career, a smart investment, only more fetishized than most. There still is some faint aura about it.

It's inflation in every sense of the word, including the crash of the art market. We're in total agreement there. And it's true that there was a core that interested me, I won't deny it. But now, contrary to what people were saying in the 60s, we are not in a civilization of the image. The word "image" is a portmanteau word: they put into it whatever they wanted, and in a certain way the word "visual" is already better than the word "image." I say that we live in a civilization of the optical. It is optics which is at stake: the structure of the visual, the audio-visual and the audio-sensa—let's just say the audio-sensitive. So, what I am saying, and this is the critique I have made in *The Vision Machine*: giving vision to a machine is the never-before-seen. When the door sees me and when it interprets my passing-by, it's the never-before-seen. Klee said: "Now objects look at me." In some way, by means of television, tele-surveillance,

spy satellites, and the world's systems of overexposure, but not only with these, we are in the process of giving vision, hence optics, to the machine. And this is an event without equal.

It's an anticipation that we didn't really see coming.

An anticipation without equal. It goes way beyond the aesthetic question.

You often quote Rudi Ruschke: "Comrades, we don't have much time left."

So this is where I stand. And I stand there with my work because this is the place where I rediscover speed. There is no optics without the speed of light. If it takes three months to morph something, there is no morphing. If it's live, if the morphing happens at once, then you enter the audio-visual auto-electronic world. And this is under way right now. This is what the failure of the visual arts—to take up Hobsbawm's term—translates. We are leaving the image behind—including the conceptual image by Warhol or Duchamp—for optics, and an optics that is *corrected*. I will remind you that the correction of optics is a phenomenon of glasses, lens-grinding, optometry. So the machines themselves have become opticians. As we reach an extra-retinal art, the machine becomes *optical*. It does not become retinal—it doesn't need retinas. It becomes optical. So the optically correct becomes a threat: the correction of sensations by machines. This is an event which calls the plastic arts into question. And I mean "plastic" in the widest sense.

The correction is not necessarily "correct" in the political sense of the word.

I use the term correction because it corresponds to optics. They say "optical rectification."

That machines recreate the olfactory sense, etc., still does not mean that machines replace olfaction.

No, it means that machines become dominant. Look at what is happening with "Big Brother." It no longer has anything to do with game-show phenomena, which are also theatrical phenomena. There is no theatre in it. Jean Baudrillard's text on *Loft Story* was excellent, by the way.[7] There is no theatre in this show. It is a problem of fascination, connected to tele-surveillance itself, exhibitionism coupled to voyeurism without the slightest distance between them. There is not even the relationship you could have with the key-hole through which you watch someone fuck another guy or girl. Let me point out that with the key-hole there still are sensas, whereas in the case of *Loft Story* there is none. So it's no longer even voyeurism. It's a purely optical phenomenon...

Eyeless voyeurism.

Yes, exactly. What's more, it's a closed-loop. And accompanied by inertia. You know what I wrote in *Polar Inertia*.[7] We are in the process of developing structures in a one-sided container, in a villa in which we are enclosed...

We're painting ourselves in a corner, so to speak, by resorting to optics.

The real failure of the visual arts is that we are moving from a civilization of the image to a civilization of optics. And when I say civilization, I should say rather *militarization*. So it's an anxiety without equal. Before there can be any hope, we have to speak out about what is happening. As long as we deny that something fundamental is taking place, we're sunk. It's conformity that carries the day. So long as the critical situation is not recognized as such, there is no hope.

What is worrisome, to my mind, is less that the visual arts have not managed to survive technology than the fact that it seems to be able to survive everything, even itself. To say it bluntly, the main objection that we both are raising about art is that it no longer plays an artistic role.

It no longer plays its role. This is also what Hobsbawm says, but from a revolutionary perspective.

The Eyes' Newspeak

Now revolution is coming from optics...

I say things that are extreme, but I can't stand it when people turn me away and say: "You're just a pessimist." They say that I am in love with despair. Horseshit. All they have to do is read my books! I am a lover of extremities, but only if we call extremity by its proper name, *extremity*; that we call evil evil, and crisis crisis. Or that we call an accident an accident. You see, the very denial reveals quite well the morphing. *A politically correct denial of the optically correct.* Behind what they openly call the "politically correct" in the States,

Europe has developed a low-intensity political correctness, since it is more legitimate in Europe to develop arguments that are critical. But, right now, this political correctness (which has nothing to do with American political correctness, I think we agree) is masking the optical correctness which is coming into being. Something that George Orwell had perfectly understood: it's not Orwell's "newspeak," it's *a newspeak of the eyes*. Side by side with the newspeak of language, there is the newspeak of the eye. You remember Napoleon's words: "To command is to speak to the eyes." Right now the machine speaks to the eyes. This phenomenon of optics can be generalized, and it is fast spreading.

The visual arts no longer speak to the eyes...

The situation I am describing is totally catastrophic, but I don't think it's the end of the world if we recognize it. If we don't, academicism has won. That is what academicism is, standards that are connected to the pressure of special interests...

Today there is an entire area of art in which artists work on computers.

I have nothing against it.

They do visual art, but they know very well that they're using pixels as a medium. Will this art be more legitimate in your eyes?

If they are able to penetrate the software, I'm not worried. If the software is still the fruit of anonymous programmers dependant on big corporations, I'm against it. I said as much to architects: so long as you don't design your own software, you guys are losers. What

do I expect of architects? That they do not follow the example of Frank O. Gehry, using the Mirage 2000 software to design the Bilbao Opera. If architects today wanted to prove themselves equal to the new technologies, like Paolo Uccello or Piero de la Francesca, they would make the software themselves, they would get back inside the machine. Whereas now they are sold the equipment, and they work with it. That's what I can't accept. This doesn't mean that I am some Luddite eager to destroy machines, not at all. I have always said: Penetrate the machine, explode it from the inside, dismantle the system to appropriate it. Here we come back to the phenomena of appropriation.

Paolo Uccello didn't take perspective as final, he started experimenting with it, multiplying vanishing points within the same painting, mixing depth of field and flatness, ultimately throwing the medieval Virgin and Child smack at the center to cover the glaring inconsistencies in his painting. He went all the way to the extreme, revealing for what it was the artificiality of the new optical code.

Perspective is the model of the artistic and optic revolution, which is at the same time mathematical. So today what I am looking for is a perspective that will give us a vision of the world.

But does the world today allow for such a stable, unifying vision. Globalization pretends it does, but it is a toss, controlled skidding with huge discrepancies and staggering unbalance. The danger of globalization today...

What is the danger of globalization? There is no perspective. There is an optical correctness being set up, and there is a generalized

tele-surveillance that comes from the military with its drones, etc., but there is no perspective in the cultural sense, as we had with a Bruneleschi, an Alberti, a Piero, an Uccello. And we have to have one, we have to do it. And it will have to be "artists," in the general sense of the word, who do it. Now that doesn't mean they will not work with machines, of course. They will have to penetrate the software. If I were to organize protests right now, I would protest against the anonymity of programmers. Who are these guys writing the programs? They tell us: Bill Gates. C'mon! Maybe Gates fiddled with a few programs in the beginning, but now it's the people in his company who write them. These people are protected: they have *bodyguards*. It's the programmers that interest me. Who are they?

The problem is how to get back into the black box.

Right back into it. Absolutely. There is no other way. That is what Piero and the artists of the Renaissance did. Except we are faced with something which we do not have the right to touch: the power of the big corporations. We would have to do what hackers do, not introduce viruses into the system, but hijack it from the inside. You see? Hackers would have to do something else other than just piss people off—like rewrite the software for themselves. And it's not more difficult. Or let's say it's just as difficult.

With respect to the arts, does this mean that, for you, the failure of the visual arts, the static arts, is irremediable? Does this imply failure as such?

No, not at all. Because perspective will make it static once again, "static" as in the hub that lets the wheel turn. Perspective is the hub of Western history. The Renaissance was the hub—Greco-Latin

and Judeo-Christian: that's the crossroads. Arab, too, because of mathematics... So I feel like saying that there is a place where the roads cross. Everything hinged on that structure, on this fixed state. But the question today is to rediscover a fixed point so it all can turn. For the moment, it's not turning.

Or you could say that everything is, flows running away in every direction. Who can tell after all that we can we still have a hub today, or that we really need one? In fact, is there still a wheel to speak of?

I think that movement is imperceptible without a fixed point. When I say a fixed point, by the way, it's a manner of speaking: it was the eye for the Renaissance. So, let me say: without an anchor point. If everything is adrift, then nothing moves.

If there is no more fixed point, then we can still devise temporary anchor points in order to keep things going. You may not be able to measure movements because you're part of it, but you become them.

The word "fixed" is not necessarily the best word. I used it with respect to the revolution of cinema, the revolution of movement. What I meant to say is a focal point. If there is no focus, no way to focus, there is no perception. Right now, however, globalization is the denial of focus. There is a kind of diaspora of sensations, a kind of fragmentation, explosion or implosion, that no longer promotes any focus, whether in theatre, or in music—you see it quite well in concrete music—or in the plastic arts; and this is equally true of architecture. So, instead, let's call it focus. But perspective is a way to focus, we agree on that, no? The line of escape is not a fixed point, it's focused.

Globalization without Vision

Rather than focus, which is spatial, I would say concentration, which is more mental. An artist doesn't have to focus on a point in space, but concentrate to find one.

I use the word concentration differently. Concentration has arisen through globalization. Globalization is a major catastrophe, it is the catastrophe of catastrophes. In the same way that time, like Aristotle said, is the accident of accidents, geographic globalization is by essence a major catastrophe. Not because of bad capitalists, but because it is the end, the closing of the world on itself through speed, the velocity of images, the rapidity of transportation. We live in a world that is foreclosed, closed off. Globalization is the world becoming too small, and not too big. We are in a world of forclusion, which explains *exclusion* in a few words. The phenomena of exclusion, repulsion, domestic and political terrorism are the equivalent of what happens in a nuclear submarine, for example, when you spend three months underwater without resurfacing. Before the sailors, captains and officers are allowed to command the "Redoubtable" or the "Corpus Christi" —there is one called the "Corpus Christi," it is quite amazing— they carry out very intense psychological testing because the proximity of the men in underwater incarceration, the forclusion creates hatred—despite friendship, through the forced presence, contact, impact. We are experiencing the same thing in the world, through the geographic forclusion of new technologies. It is a world closed off and closed in. We have reached the limit, and we won't get beyond it. What does this mean? Of course we will go farther (Mars or elsewhere), but the world is closed, and for good.

And this closure, this enclosure, is not perceived with an intelligence that is focused. We only perceive the totalitarian, globalitarian, and security aspects; we don't have the vital aspects, as in the world of the Renaissance. The world of the Renaissance gave rise to a *Weltanschauung*, a vision of the world. But what about us? We have globalization without vision, without a way to focus outside the focus of machines, and the machines work all by themselves. And here we rediscover the object that we never talk about: what is an object that has acquired sensations? What is an object that perceives, that feels, that reacts? It's not an automaton in the traditional sense of the word, it's the machine replacing me as perception. What is this entity? It's not a robot. A robot is just a robot, a mechanical double of a man or a dog, it doesn't matter. But *this*? It's an inanimate object that has acquired perceptions. I will remind you that the vision machine was developed for the Cruise Missile. It is not by accident if the Cruise Missile has been the emblem of the last ten years. Between the implosion of the USSR and the war in Kosovo, the key object, the Messiah object, has been the Cruise Missile on its way to strike Afghanistan, on its way to Khartoum, on its way to bomb Saddam Hussein, etc. And why? Because it has a visual mechanism. That means it has an acquisition mechanism.

It has sensors, sensations...

Well, yes. It has sensors, it has radar altitude readings to keep its trajectory in alignment, and at the end it develops perception from a sophisticated visual mechanism—opto-electronic vision that lets it see the building, the window, the door, etc.

Objects that are designated for it ahead of time...

Yes, but it is already able to direct itself according to at least three mechanisms: a traditional inertia power system—the V2 had them, an altitude reading system to maintain its trajectory, and a visual mechanism that lets the missile avoid screens (if you put a wall in its path, it will go around) and, finally, be directed to one side or the other according to the evolution of the building, or problems that come up. So the Cruise Missile is the emblem of the vision machine. It's incredible that people never talk about it, either. They talk about tele-surveillance. But they don't talk about this.

Wrestling with the Machines

Like Hegel, you choose characters who are emblematic of particular periods of technological innovation: Howard Hughes, the first technological monk, and the first victim of polar inertia, or Steve Mann, the first cyborg. In this case, there is no person to take on the role. The Howard Hughes of the vision machine is not a human being, it's the machine itself, the Cruise Missile. The emblem of the vision machine is a technological hero.

Aesthetics has become a machine phenomenon: there would be much to say about this. What is the machine aesthetics—we could discuss it with Godard. We could have discussed it with Deleuze, too. Here we are in a domain which is wonderful, but only provided that we fight against it. It's Jacob's wrestling match with the Angel. We must not lie down before the machine, we have to fight. I have had a photo of Delacroix's painting at St-Sulpice for years in my office, along with Rudi Dutschke's photo.

It's extraordinary. This is an anti-idolatry fight. I think we haven't sufficiently analyzed what this episode meant. Because those themes from the Bible are unsurpassable: Babel, the Flood, Jacob wrestling the Angel, I could go on and on. What is Jacob? When he was beaten by the Angel, he was told, "You will no longer be called Jacob, but Israel." So Abraham, Isaac, Jacob, they're the invention of Monotheism. (Jacob is the origin of Israel.) That's not nothing. It's History. We rediscover a way to focus. What does Jacob do? If anybody is clever, Jacob is. What does he do? He fights. But he doesn't get himself into a fight to the death. He is in a fight for life. He wants to remain human before the God whom he recognizes as such. This is the very image of the opposition to idolatry. He is an emblem of anti-idolatry. This is the reason why Delacroix's painting is so extraordinary: Jacob has laid aside his bow, his spear, and his shield. His combat is hand-to-hand against the idol. He wants to worship God, but Jacob wants to worship as a human being, not as a servant. What I am saying is that here is the big question: we are in the process of raising idols. In this sense, we're lost. There's no future in it. If this theme has any sense whatsoever, if idolatry really is a major theme for us, then clearly idolatry has no future. As for myself, I am waiting on those Jacobs who will wrestle with the machines, who will explode the software. But not in order to destroy the software...

Or the "programmers," like our friend the Unabomber...

Oh yeah, I read that. I have the whole thing in French. I found it in a little used bookstore for five or six francs. Can you imagine? So I bought it. Everything about the contemporary world that the Unabomber's "Manifesto" analyzes is really interesting.

He's an excellent critic.

It's not simply a question of being against him, you know? Now terrorism—no way, I'm against it. But the Unabomber can be subtle, intelligent, in touch with things. And yet his proposals are so stupid.

It's because he wasn't focusing enough.

He wasn't focusing at all. Not at all. But it's a gripping story.

He said many things that you yourself could have said.

Yes, but he didn't touch on dromology, the question of speed. And I think that dromology [from *dromos*, speed], or the dromological revolution, is a really important, a fundamental element to any solution. And we have yet to master it, otherwise we are heading for the global accident. My next three books will all deal with the accident as a positive event or element—not positive in the sense that it is pleasant to watch a bridge collapse, or a building crumble to pieces... That's not what I mean. In my opinion, we have arrived at that stage where we are faced with the accident. Between the 19th and the 20th centuries, we were waiting for war; between the 20th and the 21st centuries, we were waiting for revolution, and it came. War came: it was national, international, worldwide. Revolution was local and international. Now we are waiting for the accident. The accident has been local, but it is going to be general. So, we are faced with a great aspiration, and at the same time a great inspiration. The Unabomber is right: every epoch has a great clash, not just a stock market crash, not just a pollution that exterminates us—I am talking about an accident of knowledge

itself, in the fields of aesthetics, politics, in the field of economics, and other fields, too. The accident has replaced both war and revolution. It is the object lying in wait for our civilization. So long as art does not admit to itself that this accident can happen to it, it is kidding itself. This accident is passing through everything, just like AIDS. It passes through everything.

How would you characterize this accident in terms of art? In your essay on Peter Kassel, you wrote that his work was "opening the Pandora's Box of an endless perspective."

An insane world that has taken hold, and it runs all by itself. The machines work all by themselves. It is not a stretch to say that they reproduce themselves.

If you had to catalogue the accident of the visual arts for your museum, what would you put in it?

I don't really know yet, I never asked myself the question. But I would certainly find something if I looked hard enough. The question of silence and the question of the static are central elements. The end of the ability to focus goes with movement, deterritorialization. Art no longer has a ground. Does a groundless art still take place? This is what I developed in the text of the catalogue of Kassel's documentation: I wrote about the black hole of art, the fact that art is no longer localized. Art has always been localized on the dead in grottoes, in the interior of temples, or on the human body by means of painting (tattooing). But right now it is delocalized, like everything else. This delocalization is an inability to focus. We lose perspective in the broad sense, not in the sense of the Quatrocento.

There is a blackout on perspective and thus a breakdown of sense. In my view, perspective is indispensable to knowledge. Because it orients, it provides a sense of direction. The easiest way to make someone lose a sense of meaning, a sense of direction, is to disorient him. Like when the Conquistadors came, they began to smash up the village of the natives to disorient them. (Reread Claude Lévi-Strauss.) And when they were disoriented, they were handed over to nothing, because they no longer had a home base.

Those were territorial societies. The body itself was a territory, and both were marked ritually. Humans were born of the earth before being born of the flesh. This is hardly our world anymore, whether we like it or not. The earth is now called a stem-cell. The body is propped up from the inside with prostheses of all kinds. The only territory left is the image, or the mirage of one, since it never stabilizes. We are children of the electronic medium. For us, disorientation and chaos is what we go by.

Contrary to what people believe, we have been quite oriented. I believe the ideology of chaos is garbage. We can't do without a way to focus and a regulation system for our sensations. Absolutely not. Unless we engage in genetics and the obsolescence of the human species. In that case, we enter the last stage, which is the recasting of the living organism: the demiurge. And frankly it's philosophical madness.

What if genetics didn't go all the way?

I don't think such a thing is possible. The genetic bomb, like the atomic bomb and the information bomb, is apocalyptic. I'm not

the one who says that the atomic bomb potentially has the capacity to snuff out life, the information bomb to disorient life (everything that has been said about cybernetics, for example: read Orwell again), and the genetic bomb to undo the living organism...

In Pure War, [8] *exactly twenty years ago now, during the Cold War and nuclear deterrence, we had touched on the danger of a nuclear war. The real stake, you estimated then, is not actual war, but logistical war, "the war machine as a machine of societal non-development." The violent confrontation between the two adversaries could very well have touched off a nuclear escalation, but "given the speed at which societies—particularly the Eastern societies—are exhausted," the Soviet Block ended up crumbling, thus setting in motion the other scenario: generalized endo-colonization, non-development on a worldwide scale,* what we designate today by this euphemism: "globalization." *Similarly, we are now on the threshold of a dizzying mutation in the order of the life-sciences, but it is not certain either that it is leading us to uncontrollable trans-genetic one-upmanship. It's very much like capitalism: it is always giving us the feeling that it is going to deterritorialize everything in its path, and in the end it never goes all the way... It chickens out. Can technology outdo capitalism? Are they both running on divergent paths?*

These three bombs have the power to snuff out their source. But this power is potential. Nothing is preordained. In this sense, I still have hope. Within the information bomb, the atomic bomb, and the genetic bomb, it is possible to get inside the system and to deal with it in a different way. The great inventions are tragic, but we must not weep. We have to take them seriously. If you take them

seriously, you fight. You don't accept them as facts. You get inside of them, and you fight them. For the moment, we're not doing it. The Ancients did it. Whether they were philosophers, painters, architects, they fought against technology and they fashioned something else out of it.

And things got better afterwards?

Obviously, despite their efforts, we're not in the best of situations. The situations we're in are still catastrophic, but life goes on.

The Pollution of Art

The same goes for art.

The same goes for art. We have never made advances except through catastrophes. The machine hasn't changed a thing there. The internet, cars, shock absorbers, elevators, gliders, they haven't changed anything. We advance from inside the horror of abomination. And we advance, because we bring it about, and we refute it. What worries me the most right now is that there is no anxiety about pollution. True, the ecologists have made us worry about nature, that's their great contribution. But in other fields—Félix Guattari said as much—this ecological anxiety has not taken hold. There is no ecological anxiety about art. But there should be. I don't see why ecology should be little birds, flowers, the smell of the atmosphere, etc. Ecology is everywhere. Painting is ecology. Mores are ecology. Our relations vis-à-vis children is ecology, etc. It means that pollution, in the broad sense of the word, is moving through art.

Art claims to occupy a privileged position in culture, but there are too many artists by now for art to remain a privileged activity.

I agree. There is a sort of purism of culture, a purism of art…

And it doesn't correspond anymore to what is really happening to art. There's too much art everywhere for art to remain something special, the last repository of the auratic tradition. It is not even a matter of aesthetic quality, but of massive overexposure. There's too much of art everywhere. The worse is that it doesn't only concern art, as art people keep trying to convince themselves in order to preserve a last sense of art centrality. There's too much of everything—too much of too much, as Baudrillard would say. The proliferation of art, the insane inflation of museums—the Guggenheim Museum building spree, the MoMA quadrupling its space, the Whitney's expansion only are the latest examples—and current metastasis of biennales are not specific to the art environment, they are no different from what is happening everywhere else. The manic agitation of art crisscrossing the planet and pushing its wares betrays a growing sense of futility, even of despair. Art is simply losing its raison d'être.

The notion of ecology is a global notion, not a local notion connected with matter and materialism. It is connected to the mind. It is connected to aesthetics. There isn't just green ecology, but what I would call *gray ecology*. I believe there is a pollution of distances, not simply a pollution of substances. There is an aesthetic pollution. We would understand nothing about the impact of advertising without involving "aesthetic pollution" in its fundamental sense. "Aesthetic pollution" doesn't mean that it's ugly, or that it's beautiful. It means that *it interferes*. What is pollution? It's interference. So

the modern world interferes in art, as in mores, as in inter-personal relations, etc.

What would an ecology of art amount to then—stopping the interference altogether? It's impossible.

The ecological idea has entered the realm of matter, but it has failed yet to enter other realms. The pollution of the life-size is not of the same nature as the pollution of nature. Polluting the water, the air, the fauna is one thing, polluting dimensions is another. The pollution of distance never stops contracting the world. It has to do with closure. People believe the world has no end, but it not true. The world is more and more closed and more and more contracted.

The art environment has actually contracted since it started covering the entire planet. One could even say that it has expanded at the expense of art itself.

What I am saying about distances is also true of sense and meaning. There is a pollution of meaning. The television is more and more polluted and "reality-shows" keep only adding to it. But for me, the key element is the accident. Well, you could replace accident with "sin," but let's call it the original accident. As soon as there is invention, there is accident. The contrary emerges. Not simply in the field of transportation and transmission, but in the field of the transmission of meaning, in the work.

So there's a kind of reversal. Expansion turns into retraction, progress into disaster, speed into polar inertia. It's not only cars that crash.

Disasters can happen in slow motion.

I am trying to bring home that there are both. I believe that you can't create good without creating evil. It's like the top and the bottom of a surface. You can't take away the top and leave the bottom. You can't create the positive without creating the negative. Why do people censure negativity? Why don't they look for it each time there is something truly original? Including in my own work. Where is Virilio's negativity when he talks about dromology? This really interests me. That would be a real critique. Negativity is a positive task.

What is the negativity of negativity?

When you invent a concept, an art, a sculpture, a film that is truly revolutionary, or when you sail the first ship, fly the first plane or launch the first space capsule, you invent the crash. So, it's not simply a footnote on the "Six O'clock News" when they show the Concorde catastrophe, it's a phenomenon happening every moment. And so long as we do not recognize this ambivalence, we can't make progress. When Duchamp does the "Nude Descending a Staircase" or the "Big Glass," he invents something, and at the same time what is its accident? What is Duchamp's accident?

Well, the "Big Glass" got cracked.

The Museum of Accidents

The Museum of Accidents

Negative Monuments □ The World Trade Center Was an Accident □ The La Villette Slaughterhouses □ The Writing of Disaster □ Pixelization

You put together an exhibition called "Unknown Quantity"[1] *which is opening today at the Fondation Cartier in Paris. It is the blueprint for a project that you have thought about for a very long time and called:* The Museum of Accidents. *The show is made up of various footage of catastrophes lifted from the news: September 11, Chernobyl, etc. as well as of a number of art films in the same vein by Bruce Conner, Tony Oursler, Wolfgang Staehle, Peter Hutton, etc., all dealing with accidents. Last night I heard a visitor say: "Virilio had us come all the way here to watch the news." And that's indeed what it is about. Altogether newsreels and films are meant to present what you called the other day a composition of accidents, of catastrophes.*

A composition of catastrophic speeds.

Is this composition catastrophic enough for you?

Negative Monuments

I will answer outright: that is precisely why there should be a Museum of Accidents. The exhibition here at the Fondation Cartier pour l'Art Contemporain is not the museum I have in mind. To do that would require a colossal amount of work, with scientists, philosophers, the military, etc., collaborating. This exhibition merely is the *prefiguration* of the Museum of Accidents for which I have petitioned for twenty years... And I did say *twenty*.

Lucky the global accident didn't happen in the meantime. Although we're certainly getting there.

So, what does it mean? It means tearing natural or artificial catastrophes out of the realm of the tabloid press, the scoop hungry "Six O'clock News" or "Prime Time" and stage it. But this exhibition is just a preface, a sketch, a giant kaleidoscope. To illustrate the phrase by Freud, "Accumulation puts an end to the impression of chance."

You put this sentence in the hall of the exhibition. Freud wrote it in 1914-15, and it was followed by an unprecedented accumulation of disasters, wars and exterminations. And you obviously don't believe that these were mere "chance" events. Can a discrete quantity of filmic documents and art videos crammed in a dark space underground at the Fondation Cartier, like a bomb shelter or Plato's cave, manage to suggest the enormity of what is happening under our very eyes? Because the most horrifying may not even be perceptible. Svetlana Aleksievich, in the discussion you both had in the film who gave its title to this exhibition, recalls the strange sensation she had entering the zone of

Chernobyl. In spite of the tumble of helicopters and armored cars, there were no enemies to be seen—and no obvious casualties. The dead were walking, they only were victims in time. I just read that a handful of them has even chosen to return there to live as if nothing ever happened, growing their own vegetables and drinking the rain water that leaks from the 10-story high steel-and-concrete sarcophagus constructed over Reactor 4 in ground-water and eventually drains into the Dnepr, the water reservoir for Kiev. The catastrophe is all the more ominous for being invisible. It reminds me of artist Alfonso Jarr who took thousands of horrific pictures of the genocide in Rwanda, but finally decided to simply bury them all in black boxes that he exhibited in the dark. There was nothing to see either, and it was a far more powerful statement than any attempt to bring all the atrocities out in the open, as the press did. By the same token, art itself became a casualty of the massacre. But can one nail accidents in a museum, like butterflies?

Obviously this is not the Museum of Accidents I was thinking of. I resorted to using the archives of the French National Audio-Visual Institute (INA) and the Agence France-Presse (AFP) because scientists do not keep documentation on their own disasters. It would require a legal depository of major catastrophes that would be the equivalent of the legal depository of war archives. There are war museums, and now there needs to be a Museum of Accidents, because the World Trade Center is the equivalent of a war. It signaled a significant change in the nature of conflicts. Auschwitz and Hiroshima were declared the heritage of humanity—and rightfully so; they are *negative* monuments—but now we must also recognize major accidents, which are the fruit of human intelligence, the fruit of human effort, the heritage of humanity. They are not the result of error but, I would say, of complete success.

What does negative exactly mean for you?

It means that we remember in order not to do it again. The pyramids were preserved in order to remember the tyrannical character of the Pharaohs, who wanted to live forever. And History has been anxious to preserve this memory of Egyptian civilization. The same goes for the Greeks, the Middle Ages. As for us, in the 20th century, we have begun to preserve the concentration camps. Hiroshima, Auschwitz are negative monuments. For me, it's an extraordinary advance. I led a campaign in France to classify "historical monuments" as negative objects. I am talking about the fact of preserving its negativity, to catalogue it as negativity for the museum. They're finally taking into consideration the accident in the history of historical classification. It's a momentous event. The duty to remember is no longer simply remembering the great poets, the great painters, the great leaders, etc. Now it's the memory of Evil, too. There is a memory of Evil, in the mythical sense of the word. The same goes for Chernobyl. The accident begins to have a place in history, through its memory. So it begins to have a place not simply as an accident, but as an element that runs parallel to positivity. Here we find ourselves in another logic that touches on everything.

Quite a few attempts in that direction have made by sculptors and architects in Berlin and elsewhere over the last twenty years. Positive monuments often seem to work at counter-purposes, more meant to alleviate the guilt than account for the deed. I will except one pretty bewildering attempt, because it testifies to the irrepressible logic of memory when it is being recycled in the present. I am talking about the memorial to the victims of WWII that was erected in the late 50s

in Vienna. Some thirty years later, the ways people viewed the war having somehow changed, it was pointed out to the municipality that this memorial made no reference the extermination of the Jews. The same sculptor was eventually asked to supplement his work with an extra element that would account for that. He chose to make the statue of an old bearded Jew in traditional garb with skullcap. The old man is shown sweeping the floor with a broom, his back bent pretty low. It was so low that tired tourists got into the habit of sitting on it. A new row of complaints ensued and the hard-pressed municipality decided to deal summarily with this embarrassing situation. They surrounded the Jew with barbed wire. To me this desperate attempt to repair the desecration by committing a new one was the best possible memorial to what had been done to the Jews and they should have kept the barbed wire right there. Possibly unroll it around the entire city of Vienna while they were at it. It took a long time for Austria to face up to its own responsibilities in the war and this turned out to be the perfect monument to what they had done because they had done it again. *This monument couldn't have been conceived beforehand, and no one was really responsible for it—it was kind of the death of the author—but it was implacable. This may have been also what the Actionists had been trying to do in their own way by torturing their body publicly.*

I would agree with you. I think there's some parallel between the duty to repent, between the classification of the camps as negative monuments, and Actionism. Otto Mühl and the Viennese Actionists are people that mimic in the flesh negative situations. Self-mutilation is a negative act. So, there are some subtle issues at stake in their work.

The World Trade Center Was an Accident

It isn't surprising that the duty to memory would have become such a crucial issue since it is contemporaneous with the achievement of "real time" of the media. Instantaneous communication achieves a "negationism" of another kind, less political than purely aesthetic. You suggested that much in your essay on Peter Klasen. It is a real industrialization of forgetting that is being orchestrated on a huge scale in the present, and it makes it all the more necessary to pay attention to the accident. Accidents used to be considered an exception, something that shouldn't have happened and would take everyone by surprise. You see them on the contrary as something substantial, even rigorously necessary. Moreover they're bringing out in the process the real nature of technology, dismissing the delusions of progress and optimism. According to you the accident isn't just a question of if, but when. It is true of terrorism, which adheres to the same logic as it increasingly relies on speed and technology.

This is an Aristotelian exhibition: the more effective, the more performative a substance is, the more qualitative it is and the more the catastrophe is quantitative and pernicious. It is the shadow cast by genius, and this shadow has began to illuminate the earth, because the earth has been reduced to nothing. Reduced by what? By acceleration, by speed. This exhibition is the conclusion of the exhibit on "Speed" [La Vitesse] that we presented in Jouy-en-Josas in 1991. When you work on speed, you work on accidents. Why? Because there is a loss of control. What is speed, what is acceleration? A loss of control and emotions just as much as a loss of transportation. A plane crashes because it is out of control and crashes more surely the faster it is going. An

old airplane, a glider, merely glided; it would fall because of a mistake by the pilot—or not even the pilot, let's say the glider's passenger. But now we are caught in a race for speed, which means we have not only accelerated the means of transportation, the means of production and the means of information, but we have also accelerated the catastrophes themselves. The question of time and of the privilege of fast-speed is daunting because we have the tendency of losing our power of control. Today the technologies of real time are preventing us from judging directly and we don't have any choice but transferring to an ultra-fast machine the power of perception, the power of acquisition and the power of decision. This shift of political power in favor of the machine is forbidding. Catastrophes have accelerated with the acceleration of substance. That is why we need a Museum of Accidents.

We may already have it: it is the world we're living in. But it will be a museum for others, Martians, extra-terrestrials, visitors from outer spaces, who would pay it a visit after our civilization crashed. The accident is no longer local, it is global and permanent, like the sinister satellites that keep orbiting the planet, or the drunken driver whom you quote in your introduction: "I am an accident looking for a place to happen." Accidents are bound to happen and the only question is when and where. But whenever we become aware of something, it's already too late. Accidents are not in the accident, they always precede it.

We can no longer ignore the fact that in the 20th century, we have gone from a symbolic local accident—the "Titanic" sinking somewhere in the North Atlantic, taking fifteen hundred people to the bottom—to a global accident like Chernobyl, or even what

is taking place presently in genetics or elsewhere. We used to have *in situ* accidents, accidents that had particular, specific impacts; but now there are general accidents, in other words *integral* accidents, accidents that integrate other accidents just as Chernobyl continuously integrated the phenomenon of contamination. And if the heroic "liquidators" who put the sarcophagus on the reactor hadn't managed to do it, all of Europe would have decayed. With Chernobyl we had—but we could just as well use the example of the World Trade Center—a major accident. Why? Because it is a temporal accident. In terms of place, there was an accident, a local one, Chernobyl, Pripiat, Bielorussia, but on the temporal level, there was an *astronomical* catastrophic phenomenon taking place—the radionuclide takes centuries to disappear. We were faced with an unprecedented accident and it was a prefiguration for other types of accidents such as stock market crashes that are interactive phenomena. And I would insist on this: interactivity is to information (in the fundamental sense of the word information) as radioactivity is to nature.

What interested me in the visitor's passing remark at the opening is what you didn't exhibit: static documents, or staged debris, the modern equivalents of romantic ruins. It was not a representation of the accident, but a presentation of it in action. You're bringing out the accident through the same medium as the accident itself.

Precisely. Here is an example of the Museum of Accidents. (Virilio points to an AFP photo of a Boeing 747, a TWA accident meticulously reconstituted in a huge warehouse after it mysteriously crashed at JFK on November 19, 1997.) It is a Museum of the Accident, as if we were trying to read "the Writing of Disaster,"

to take up Maurice Blanchot's expression. We are picking up all the pieces to reconstruct *what has happened*. (It is the etymology of the word accident.) I propose the same thing, not at the level of a fuselage, but of what happens in the world. Why? Because now all accidents are *major*, they are no longer minor. The "Titanic" was a minor accident whereas current accidents are major, all of them, by virtue of their power. This photo is emblematic, and I put it on the cover of the Cartier catalog. It looks like an Andreas Gursky. When we prepared the English version, the editor of the *Times* told me, "I cannot put that photo on the American edition." I said, "What? It is my photo, I don't have any others. And then, what's more, we used it for the French edition." He said, "No, I don't want to be sued by TWA." So I replied, "Listen, that's not my problem." And he said, "I'll look into it." An hour later, he called me back. "Paul, he said, it's great, we don't have any more problems." I asked, "You came to an agreement?" "No, there is no more TWA." So you see, that is the truth, and the truth will set you free as Christ said. This exhibition is not a gadget, it is dead earnest.

You're setting up an investigation parallel to the one carried out by specialists in catastrophes.

Yes, but it is on the cultural level. When you build a car, you do crash tests to improve its performance, its safety, especially its performance when it turns, the way its holds the road, what happens during impacts, etc. My exhibition is a cultural crash test, not only functional but cultural. The same could be said of contemporary art. It has been crashing since World War I, a war victim through Expressionism, Surrealism, Viennese Actionism,

and terrorism today. Now it is time to recognize that we are victims of major accidents, and war is one of them. But today, accident and war are the same thing. You just have to look at the World Trade Center.

You remember Stockhausen's unabashed comments on the World Trade Center attack. He said that it was the most beautiful work of art ever made. So there again, technology, accident and the work of art join together beyond good and evil. The media is only tragic to the extent that it deals with catastrophes and accidents. Otherwise it is just some kind of freak show. Little stabs of gore sandwiched between Bud and Bush. It's the aesthetics of disappearance.

That is all it is, but there is no thought behind it. And that is why I say the accident has to be *exposed*, to play on words: exposing oneself to accident or exposing the accident. The major accident is the Medusa of modernity. To look the Medusa in the face, you have to use a mirror. Its face has to be turned around, and this is the aim of the Museum of Accidents. That is not what the media does because they deal with scoops and sensationalism.

Do you know Géricault used to hang a flayed piece of ox in his studio in order to get in the mood to paint "The Raft of the Medusa"?

"The Raft of the Medusa" is a tragic work, like Jacques Calot's "Disasters of War," or Hieronymus Bosch, or "Guernica." I am not the author of this exhibition.

The La Villette Slaughterhouses

One of the ways you chose to bring out all of this is by overexposing *the materials. In your exhibition, every screen speaks of catastrophes, as if nothing else existed in the world. You overexposed the accident to make it appear for what it is: relative and unexpected, but necessary.*

I did that because the accident is censured. I should mention that I am doing this here because the Museum of Science and Industry in La Villette did not.

La Villette used to house the famous Paris slaughterhouses.

And the slaughterhouses became the Museum of Science and Industry. But let's go back to the beginning. It all started with Three Mile Island, Harrisburg. In 1979, I wrote an article for *Libération*, where I had good standing at the time, a full-page article: "The Original Accident," saying that it was urgent to question the idea that the accident is relative and contingent. Each invention creates the possibility of a specific failure. I suggested that we should imagine a prospective of the accident, and even directly invent the accident in order to determine the nature of the invention. I had a show on the RAI, the Italian television. They asked me to do an interview on speed and technology. "Where do you think we should do it?" they asked. And I said, "In the ruins of the La Villette Slaughterhouses." The program was aired and it so happened that the Left took over the French government. The idea was put forward for what was to become the Museum of Science and Industry. At the time, François Barré, who was close to Jack Lang, the Minister of Culture, asked me, "What do you think should be done." I said, "Simple. You've got

to integrate the Museum of Accidents into the Museum of Science and Industry, require that each discipline—chemistry, biology, physics, mechanics, automatism and everything—should present its own genius, and its horrors, in their proposals. This genius and this horror belong to science." I am aware that Jack Lang introduced in the competition guidelines a sentence that hinted at that.

Obviously, it did not happen. Why? Because it is not marketable. Since science has become techno-science, it sells products. Selling them is not scientific, which is why they were censured. Then, in 1986, the Museum of Science and Industry opened in the La Villette Slaughterhouses—a symbol, for those like me who have the war in mind. That year, we had Chernobyl and the Challenger. The original accident of a space shuttle, a sign in the sky. So I wrote a text, "The Museum of Accidents." I used *museum* on purpose, a museographic term. In 1991, the Fondation Cartier got in touch with me. "We are doing an exhibition on Speed with a catalog and everything. You are our inspiration for it." We did a fabulous exhibition. What happened ten years after follows the same logic. Hervé Chandes from Cartier told me, "You have to do an exhibition. What do you want to do?" "The Accident. I have done an exhibition on War and Bunkers; I did an exhibition on Speed; the Accident will be my last one, because the three go together. I have nothing else to say." He said, "All right, we'll see." And then came September 11.

September 11 is an accident emblematic of the current disorder. Why? Everyone tells me that it is not an accident. But it *is* an accident. Unlike the first attack against the World Trade Center, there was no missile, no bombardier, no explosives. And there were three thousand deaths, more than Pearl Harbor. Pearl Harbor left twenty-five hundred dead, aircraft carriers, torpedoes, bombs, Super Zeros, etc. In 1993 two Islamic Fundamentalists already tried to bring

down the World Trade Center. What did they want to do? Going back to a transcript of the trial, which I have, I realized it right away. What they wanted to do then was even better than September 11. The transcript states that they brought in a Ford van, a rental, only a few dollars, not even purchased it, and they filled it with 600kg of explosives. A joke: you can find that on any public works site or mining operation to blow up rocks. They go down the World Trade Center access ramp—the three of them, or four—and the charge explodes too early.

They weren't able to get to the right place. I remind you that the World Trade Center did not have cement columns, which means that the structure was extra-fragile. So what did these people want? They wanted to knock over the first tower so it would fall into the second and *then both collapse onto Wall Street*. How many deaths did they expect to inflict? Just do the math! I'll do it quickly for you. There were approximately twenty-thousand people in each tower, which means forty-thousand dead in one blow because both would have collapsed. There would be nobody left, no firemen in this case. The towers would have crushed entire blocks. They calculated the cost/efficiency ratio: three men, a van, a few dollars, 600kg of explosives, two hundred fifty thousand deaths. The cost/efficiency ratio is better than Hiroshima, better than Dresden or Hamburg. The September 11 attack was an accident that was carried out from above since explosives were not reliable enough. With terrorism, the new mass terrorism, accident is used in lieu of weapons. The fragility of modern societies is such that there is no need for missiles or aircraft carriers, it is enough to give a few men some box cutters—nineteen men, two planes, crash bang! Three thousand dead. Accidents are no longer minor, they are major.

The Writing of Disaster

And this is what you tried to show with this exhibition by bringing together what are generally referred to as exceptions? Then the exception would become the rule…

It is hidden, I would say, in the usual flow of information. There is continuous catastrophic information. This catastrophic information is a new knowledge, one that is hidden: it is the "writing of disaster." The point is not to cause fear, the point is to read the writing of disaster in order to oppose it.

The various interruptions have to be connected like a dotted line in order to make sense.

The interruptions have to be connected to reach a prospective knowledge of the threat. The threat of what? Not of terrorists! The threat of *our* own power, of *our* arrogance. The strength of the terrorists is our pride. The hubris of someone who builds a twelve hundred foot tower—an extraordinary feat—with no cement core. In France, you are not allowed to do that. I am the director of the École Spéciale d'Architecture in Paris, and we do not have the right to do that. The Montparnasse Tower is in cement. It obviously moves in the wind, but not much. It moves; it does not vibrate. The World Trade Center vibrated, suffered when there were storms in New York. I have a cassette that Stephen Vitiello gave me. He is the one who did the sound for the Cartier exhibition. Months prior to the attack, he put sensors on the towers, and you can hear them during the storms. You hear them on the cassette. You can hear the suffering. It is an ideal performance. Twelve hundred feet,

that's higher than the Eiffel Tower. Without cement. It is a feat *at the expense of solidity*. It is exactly like the Rum Road with the Tri-marans: eighteen at the start, three at the finish. I repeat, our slowness is our power.

Aristotle thought that "substance" was absolute and the accident rela-tive. For you it is the reverse.

The accident reveals substance. We could replace the word *reveal* with the word *apocalypse*. The apocalypse is a revelation. The acci-dent is the apocalypse of substance, in other words, its revelation. To put it another way, the revelation of the World Trade Center was its suffering as a performance. It was extraordinary to build twelve hun-dred feet without a structure, with a simple steel weave. But this performance came at the price of an unprecedented catastrophe.

It was a challenge, but they did not anticipate its reversal.

No. There is a sort of human sacrifice in performance. I will take an example. Take a plane now, since planes were what they used. Airbus is getting an eight hundred or one thousand seat airplane ready and someone asked my opinion. I said, "Eight hundred deaths." They replied, "Stop! You always look at the bad side." I said, "Are you kidding me? Listen, let's do a *thought experiment* and I will offer you a solution." You know what a thought exper-iment is, they are not common enough. Physicists are not the only ones who should do them; philosophers should too. Take a thou-sand-seat airplane, that makes one thousand dead. You accept it, the proof being that you find I am exaggerating when I say one thousand deaths. Which means you accept it. Which means that

the passengers are going to accept your sacrifice: they are consenting victims. Maybe myself included, it's possible, if I need to get to New York. Let us go a step farther. Not very far, in fact. Just a century ahead is enough. We have invented a flying super-island that can travel at hypersonic speeds. You can travel, for example, to Tokyo in two hours, or even one hour, for one Euro. This is a thought experiment. The island is so unheard-of that it has to be made into a mass phenomenon. So I will exaggerate the figures: rather than one thousand people, let's say, for example, ten thousand. Do you take the risk? Well yes, the cost of transportation, etc. All right. Then we go even further. We make an even bigger island. We put forty million people on it, you take the risk. It is obvious. Progress in air transportation is a tolerable sacrifice until the day you tolerate it no longer. It is the same thing with nuclear energy. Now we are giving it up: the sacrifice is no longer tolerated. Ecologists are the only ones saying it. We are in a cumulative phenomenon that is in the process of creating an integral accident, let us say, in general terms, of substance. But knowledge? "Science without conscience is but the ruin of the soul," wrote Rabelais. We are confronted with the accident of knowledge.

This catalogue, "Unknown Quantity,"[1] *is about the accident, but there is an accident of art too. Your warning to contemporary art has been quickly dismissed as if it was just an aesthetic judgment. It was also often attributed to your ignorance of contemporary art, which is hardly the case and we have documented that earlier. It is true that few artists today would turn to the Impressionists for a model, but you merely see them as paradigmatic of the kind of mutation that is expected from art today. Actually thinking back on the discussions about art that we've had, I was struck by how coherent your argument*

*was. This hasn't been acknowledged enough by those who dismissed
your criticism a little lightly.*

I have faults, but I do not think one of them is incoherence.

*In your previous books you brought out the importance of the inter-
ruption. If we didn't blink, we wouldn't be able to see. We would be
glued to the screen. Interruption is what allows us to take our distance
and reclaim our consciousness from the blindness of sight. Movement
and stasis feed into each other, like the feeling of stillness and security
that comes from going on high-speed on the highway. Interruptions
wake us up from the delusions of control. This is also the function you
attribute to the accident. It forces us to think.*

It is part of the accident of knowledge. The accident of art is the
accident of knowledge.

*The problem now is that there are no possibilities of learning from it.
You said earlier that we do not believe our eyes: we could still believe
our eyes if we could close them. But they are glued to the screen.*

That's right. Overexposure is the live broadcast, it is real-time
replacing the past, present and future. A society that heedlessly
privileges the present necessarily privileges the accident, etymologi-
cally: *that which happens.* So somewhere the end of the future and
the end of the past, in our societies of immediacy, of ubiquity, of
instantaneity, are necessarily the advent of the accident. The live
broadcast is a catastrophe of time. When I say catastrophe, there is
a positive element in it, but it is frightening at the same time. And
this "double bind" is the new form of tragedy. Positive progress is

always bearable, but accidents become unbearable. This is what has happened with nuclear energy and it has led Germany to close its reactors. This is a considerable event. This shift will lead to others that are not in the field of energy.

The accident always happens in the present, but is untimely.

But at the same time, it isn't fatal. My work is an attempt—either for scientists or artists—to move beyond the observation and look the Medusa in the face, what St. Paul said will happen to us. Paul used a phrase—an extraordinary phrase for our time: "You will be saved"—in other words, you will pass on, you will not dissolve—as if by fire. You have to look the fire in the face to go through fire, like the clowns who jump through a ring of fire. The ring of fire is globalization, major accidents. It is Hiroshima, Auschwitz, etc. If we turn our eyes away, all is lost. You have to jump through the fire, not to destroy yourself, but to keep hope alive.

Is there not a danger of being fascinated by fire?

Of course, but the danger exists. Suicide bombing is a fascination with death, an eschatology. I have great fears. There is already a party of the accident, the Green party. But they do not know where to stand, whether to go on the left or the right. I am afraid that after that we might have a second party, an Eschatological party of which Nazism was a *less sophisticated* foreshadowing. And I do mean less sophisticated. Hitler was a novice compared to the eschatological parties to come. This Eschatological party was formed in a confined area, around Auschwitz. Today, it has reached the level of globalization. Next to the Green party, there

is the risk of having a Black party. The suicide bombing—which at present is Islamic, but could be something else tomorrow—foreshadows the Eschatological party, in other words, the hope for an end, for nothingness. A nihilism reaching far beyond Slavic nihilism and even Nazi nihilism. Because it's about exterminating.

When you camouflage death, it comes back all the stronger.

You have to look death in the face, which means passing through fire, and that requires—if you are not fascinated by death—a hope that reaches beyond hope. I believe that, to a certain extent, you cannot understand the level reached by new technologies, by the power of human intelligence, without some knowledge of spirituality. Prehistoric people looked dinosaurs in the face. Our dinosaurs are our shadows, the shadows of our own intelligence. And I remind you that dinosaurs died in a cosmic accident.

Notes

A Pitiless Art?

1. Michel Cassé, *Du Vide et de la Création*. Paris: Editions Odile Jacob, 1999.

2. Jean Baudrillard, *The Conspiracy of Art and Other Texts*. Trans. Ames Hodges, New York: Semiotext(e), 2005.

3. Paul Virilio, *Art and Fear*. Trans. Julie Rose. New York: Verso, 1994.[*La Procédure silence*. Paris: Galilée, 2002.]

4. Peter Klasen/Paul Virilio, *Impact Inspections*. Angers: Expressions contemporaines, 1999.

5. Paul Virilio, *The Strategy of Deception*. Trans. Chris Turner. New York: Verso, 2001.

6. Louis-Ferdinand Céline, "Dead Man's Dance," in *More & Less 3*, 2002, special "Hallucination of Theory" issue. Art Center College of Design, Pasadena, Ca.

7. On June 10, 1944, the SS division "Das Reich" massacred the population of Oradour and burned down the church where they had packed women and children.

8. Jean Baudrillard, *The Spirit of Terrorism*. Trans. Chris Turner. London: Verso, 2002, p. 9.

9. Jean Baudrillard, The Consumer Society (1970). Trans Chris Turner. London: Sage Publications, 1998

10. André Malraux, *The Voices of Silence*. Trans. Stuart Gilbert. Garden City, N.Y., Doubleday, 1953.

11. Jean-Jacques Abrahams recorded the hostile reactions of his psychiatrist, including his call to the police, after he showed up at his office with a tape-recorder. See, "Fuck the Talkies," in *Semiotext(e) #7* ("Schizo-Culture" issue), New York, 1978.

12. Paul Virilio/Sylvère Lotringer, *Crepuscular Dawn*. Trans. Mike Taormina. New York: Semiotext(e), 2002.

13. William Burroughs, *Burroughs Live*. New York: Semiotext(e), 2002, p. 490.

The Accident of Art

1. Henri Lefebvre, *Everyday Life in the Modern World*. Trans. Sacha Rabinovitch. London: Transaction Publications Inc., 1994

2. Eric J. Hobsbawm, *Behind the Times: The Decline and Fall of the Twentieth Century Avant-Garde*, London: Thames and Hudson, 1998.

3. Paul Virilio, *The Vision Machine*. Trans. Julie Rose. Indiana University Press, 1994. *The Art of the Motor*. Trans. Julie Rose. Minneapolis : University of Minnesota Press, 1995.

4. *Loft Story* is a reality-show which caused a lot of controversy in France. Jean Baudrillard' essay "Telemorphosis," can be found in *The Conspiracy of Art*. Trans. Ames Hodges, New York: Semiotext(e), 2005.

5. See: Chris Kraus, *Video Green: Los Angeles or the Triumph of Nothingness*. New York: Semiotext(e), 2004.

6. See: Paul Virilio/Sylvère Lotringer, *Crepuscular Dawn*. Trans. Mike Taormina. New York: Semiotext(e), 2002.

7. Paul Virilio, *Polar Inertia*. Trans. Patrick Camiller. Thousand Oaks, Calif.: London : Sage, 1999

8. Paul Virilio/Sylvère Lotringer, *Pure War*. Trans. Mark Polizzotti. New York: Semiotext(e), 1983.

The Museum Of Accidents

1. Paul Virilio, "Unknown Quantity," Fondation Cartier pour l'Art Contemporain, 2003.

Index

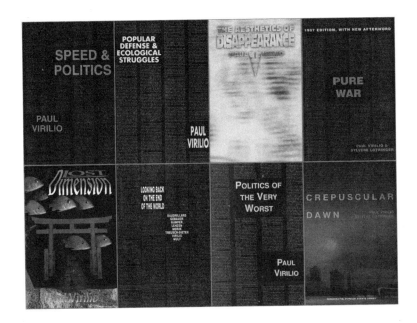

Other Semiotexte Titles by Paul Virilio

Speed & Politics

Popular Defense and Ecological Struggles

Aesthetics of Disappearance

Pure War

Lost Dimension

Looking Back on the End of the World

Politics of the Very Worst

Crepuscular Dawn